For Kyffin

Portraits of Artists
Nicholas Sinclair

With an essay by Ian Jeffrey
and Nicholas Sinclair in conversation with Robin Dance

Lund Humphries

First published in 2000 by
Lund Humphries
Gower House
Croft Road
Aldershot
Hampshire GU11 3HR

Lund Humphries is part of Ashgate Publishing

British Library Cataloguing-in-Publication Data
A catalogue record for this book is available from the British Library

ISBN 0 85331 799 2

Designed by Chrissie Charlton & Company
Typeset in Foundry Sans by Tom Knott
Printed in Great Britain by BAS Printers, Over Wallop, Hampshire

Ashgate US office:
Ashgate Publishing Company
131 Main Street
Burlington
VT 05401
USA

Distributed to the book trade in North America by
Antique Collectors' Club
Market Street Industrial Park
Wappingers Falls
NY 12590
USA

Contents

Fine Art by Ian Jeffrey

Why should we want to look at portraits of artists, rather than at those of rugby players, singers or architects? Perhaps because the artist is something of an enigma, and we feel that by looking at a reliable portrait we can see through to the creative source. No, we never learned that much from a photographic portrait of an artist. Look at it this way instead. The photographer too is an artist, even if we don't always give credit where it is due. What this means is that you are faced by a portrait which is in itself a work of art, a worked surface contrived with respect to another artist. To what extent, we should ask ourselves, has the photographer either stood aside or bowed out on behalf of the subject? Who had the upper hand? Who came away unscathed? Did the photographer escape and emerge at the end of the day as an artist, or was the issue never decided? Bill Brandt, who was a great photographer of writers and artists in the 1940s for *Lilliput*, made sure that the decision went his way. The subject was always manoeuvred and managed to the point that it became one element among many, passive material in a Brandt composition, rhymed with a clock on the mantelpiece or fitted into a wallpaper pattern. Nicholas Sinclair is an altogether kinder artist, but nonetheless a composer in his own right. It would be a mistake, that is to say, to look at these pictures simply as 'portraits of artists'.

He is, it must be admitted, capable of some degree of self-effacement. There is, for instance, a marvellous portrait of the sculptor Anthony Caro, in which he has – it seems – tried to put himself at the service of the artist and his works. In it, Caro sits under a collection of metal hoops and arcs supported against the background wall by a metal bracket. It seems to be a lot of metal to be held by such a small bracket, and the ensemble even looks threatening – like a blow-up of an ant or wasp advancing on its prey. Turn the dial though from 'Hollywood' to 'sculptor' and the threatening mandibles become calipers, signs of gauging and assessing. Turn it still further to 'art' and your screen will deliver Malevich or one of El Lissitzky's diagrammatic and educational *Prouns* from those halcyon days in the 1920s. The artist himself, seated under this evocative apparatus, confronts you with as level a gaze as you are likely to meet anywhere. Whether by intention or not he has tilted his head slightly to his right so that his eyes and brows continue the line of the arc behind him. His body, at the same time, seems to have

been arranged to counterpoint or mirror what looks like a sheet of painted metal to the left. How excessive, you might think, to read so much into a portrait. Surely he just happened to be sitting like that? But the sculptor himself would be disappointed if you or any other onlooker failed to attend to the physical presence and arrangement of parts in any of his own works. Look at this portrait carefully, that is to say, and you will have looked by proxy at one of the artist's own arrangements.

Albert Irvin is another artist from Caro's generation, and in his case Sinclair has also managed a composition which reflects on the art itself. It looks, at first sight, like a straightforward report on the artist in his studio. Art-school *habitués* will recognise the painted chair encrusted by long service. The table too, creaking under a weight of pots, bottles and rolls of paper, is characteristic of a working studio. How long, though, before it gives way in the middle? All the same, it makes a nice declining arc, harmonising with the curve of the chair and even with the line of the artist's shoulders. Irvin's paintings depend on getting it right intuitively, on being as sure as you can be in such a subjective business that the ensemble works together. So that series of arcs moving upwards through the picture (chair-back, belt, tabletop, shoulders) reflects on the values implicit in this kind of painting. Yes, of course, it is just a picture of Albert Irvin in his studio, but remember that he has devoted his life to painting, and that painting is a serious business, involving the transformation of basic materials into something else: the work of art, a transcendent order. Look again at the picture, even with a glass, and you will see beyond those ketchup bottles in the immediate foreground a good smattering of debris: discarded paper, shards of plastic and transparent bottles. It looks like nothing so much as a storm-wrack along a tideline. Above and beyond, out of the shadow of the table, the painting itself unfolds like some kind of a mountain landscape, mist in the Dolomites, perhaps, or snowfields seen from an Austrian road.

At the same time it is a portrait of Albert Irvin, a representative and more than presentable-looking man in jeans and a checked shirt. What is it to be a man? What a Shakespearian question to ask in the busy and generally practical world of British art. No, in this context of art it is perfectly justified. The human project, to put it very simply, has

always involved a contract with circumstances, with the sort of contingent details crowded together in those strata at the bottom of the picture. We cope with them, put them to use and from time to time make of them something discrete and distinct – art. We are, you might say, physically arranged along these lines, heads in the air the better to oversee the fabric of the place in which we find ourselves. Delacroix thought about little else, or at least he always tried to mark an idea of humanity in his pictures. There is a painting in Dublin, for instance, *Democritus Walking on the Seashore*, in which the artist has been careful to show the head of the scientist above the horizon; and this was always Delacroix's way of making a distinction between ourselves and the rough-and-ready environment. Sinclair's painter, Delacroix-like, rises into the empyrean or visible heavens, and you will see that the sun even touches his brow, confirming that this is far more than a portrait of an individual painter momentarily turned aside from his work.

But if Irvin is presented as a representative and symbolic figure rising above the material life of the studio, what are we to make of Caro barely acknowledged on the lower edge of his portrait? Sculpture has always been about the physical act of raising up. You might call it hubristic and potentially dangerous – literally so in this sculptor's studio. These seem to be extravagant and fundamentalist terms to apply to a set of portraits. Are they justified, and do they bear any relationship to the photographer's own ideas? There is plenty of evidence to suggest that this is indeed exactly how the photographer thinks. There is a portrait of Paula Rego, for example, seen against the background of one of her own paintings in which a woman, head inclined to the side, holds steady a ladder. The painter, for her part, looks upwards and out of the picture, contradicting the earth-bound gesture and glance of her creation. Anish Kapoor too seems to be engrossed in the same drama of transcendence, although on a downward curve, taking stock among the elements.

Not every one of Sinclair's portraits negotiates the up and the down, or transcendence and materiality. Nevertheless, he seems intent, whenever possible, on saving an idea of art – either his or theirs, or just the idea in general. Edward Allington, a sculptor, stands outside his studio. To the rest of us he could be just another figure in the street asked to pose for his picture. Note that 'classical' photographers such as Nicholas Sinclair scrutinise pictures to a degree that would be surprising to most of us. It is not just a question of pre-conception but of discovery post-facto. The picture might reveal more

than you ever imagine could have been put into it. Allington, a motorcyclist, wears a leather jacket and a scarf, signs of winter weather. His hands are in his pockets, another response to the conditions on the day. If you follow his outline, he makes, roughly speaking, a hexagon, but Sinclair is far more of a materialist than he is a mystic. In that case, the most remarkable aspect of the portrait is Allington's leather jacket buttoned and creased, and oddly enough consistent with the surface of the door beyond, textured by age and ill-use and held together precariously by bolts. Overhead, and somewhat in the style of those iron hoops in the Caro picture, a strand of barbed wire picks its way across the surface, suspended on loops – a gauge of sorts, reflecting on the surface as a whole. That is to say, the picture puts on show a pattern and a repetition, a doubled action – that of flattening – which shows the picture, even if only incipiently, as a composition and more than simply an aggregate of its parts.

Sinclair enjoys visual poetics, although in his case they might be called photographics: the placing of Edward Allington in an assemblage, and the positioning of Albert Irvin as a representative Man. Kyffin Williams, one would imagine, would need no enhancement, for he looks like artists used to look in the days when they were lionised. Yet this too is more than just a portrayal, for the artist has been, it seems, placed within one of his own landscapes. By excluding the frame and any studio details the photographer implies that this is an actual environment of mountains and a lake, and that it even has its own weather, for the artist's surcoat with its raised collar looks like outdoors wear. An Olympian, Williams appears to be using a palette made on an extravagant scale, cut from floorboards, Cyclopean and in keeping with his mountain scenery. Then, very discretely, Sinclair both changes gear and gives the game away when he matches the spear-like point of the artist's palette knife with an adjacent mark in the painted landscape. We always knew it was a painting, but here is the evidence – a mark, too, of the photographer's control, and of his interest in fictions.

Perhaps, though, it just happened that way, an interesting accident of which no one should make very much. One of the problems and attractions of 'classical' photography is that it throws up evidence much of which lies outside of the photographer's intentions and which may not in the end mean very much. Conversely, of course, one of the shortcomings of arranged and studio-based photography is that it leaves no place for contingent details of this sort. You are faced by nothing more than the artist's own work,

and that can prove disappointing. The virtue of accidents and contingent details is that they suggest that there is more involved in art than we can encompass, and that the environment hosts significant details and signatures which we just might be able to read, given time and patience. There is in this set, for example, a portrait of Frank Auerbach, taken more or less in the act of painting. The work on the easel looks like a landscape with trees based on a series of six monochrome studies pinned onto a board. This is one photograph at least where you can learn something about the artist's work habits: he paints from or with close reference to drawings arranged to his right. He also uses spread newspapers, to protect the floor from spatters. A newspaper in real life is something we can take or leave, but a newspaper in a photograph is a different matter altogether, for it is *evidence* of time and place, as well as being a test of knowledge. What you have then, not so readily overlookable on the floor, is a miniature collage: three sport and one music; a cricketer, a boxer, a rugby player and a conductor. Given time you might be able to place them all and, as you were doing so, you might notice to the right, in the shadow of the chair, an inscription 'artist's fear of the penalty'. What can it mean? Nothing, you might say, to such level-headed people such as ourselves; but, all the same, any long-term devotee of photographs knows that the medium thrives on such details, remarks made by providence, which you might like to ignore but will never be able to.

Photographs have their own points to make, irrespective of ostensible topics. In an epic portrait of Eduardo Paolozzi, the artist, in a Barbour jacket as if he had just come in from the cold, leans against a half-completed figure, looking like an upright brother to the Blake-ish Newton in the forecourt of the British Library. The sculptor's hands, fingers interlinked, might almost be a detail from one of his own constructions. Down below a detached plaster hand stands in a gap on the plinth, next to a ball of string, not a detail you would associate with the business of sculpture, until one notices that the arms of the seated giant are held in place by bands of string taken from the same roll. The thighs, too, seems to be held in place by string. It must be plaster rather than polystyrene, for those look like plaster marks on his sweater. But can domestic string of that calibre hold together pieces of plaster? Apparently they can. In the process of wondering about that ball of string the piece itself has begun to declare itself as assembled material. What was originally a portrait of Paolozzi, the famous sculptor, has become, by virtue of those details, an account of the formation of the work. But for photography's garrulity and

attention to detail none of this might have emerged. Photography insists that you spend more time and look into the details, for it is only then that you will go beyond first impressions.

Photography in the documentary mode promises total disclosure. First we take stock, and then we take action: that is the documentary rubric. It is a forensic medium, but tantalising nonetheless for sometimes it stops short of total diclosure. Gavin Turk, one of the new generation of sculptors or art-makers, has placed himself on a staircase with a badly damaged balustrade in which the balusters have been misused and torn out and the ball finial on the newel post sawn or broken off: art scene details you would usually take for granted, except that they do loom large here. On the wall the kind of notice you find in re-used commercial buildings: 'IN CASE O ... ESCAPE TO A ... BUILDINGS AV ... FROM THE TO ...'. Gavin Turk is well-known for a series of plaques in the style of the distinguished residents series placed on London houses, and this precautionary message looks like a reference back to his art. What can the missing letters say? It must surely say 'IN CASE OF FIRE' or maybe 'IN CASE OF EMERGENCY'. Maybe, but does the 'A ...' in the second line refer to 'ADJOINING BUILDINGS', or is the digit count wrong? How far do you think the board extends beyond the edge of the picture? If the whole thing were on show it would, of course, be of no further interest but partial disclosure is both distracting and intolerable.

It cannot be denied, though, that being an artist now is no longer what it once was. An artist in Nadar's day in the 1850s, for instance, was likely to envisage himself, with the photographer's help, as an heroic figure, the equal to any engineer or military man. Delacroix, in Nadar's studio, posed virtually as Napoleon, and Millet and Courbet were capable of a *gravitas* never again matched in the history of painting. Hugo Erfurth photographed the great Otto Dix in the 1920s as a working painter in a smock, but Dix was also engrossed in some kind of Dionysian role. Nobody in the 1920s cared to appear authentically, for it was a great age of cinema and acting. Man Ray photographed André Derain as a gangster or a sleuth or a master-forger, and Fernand Léger as a provincial tradesman. Male painters in the 1920s favoured hats, even in the office. Picasso, as a trainee grandee, went haughtily bareheaded. (See the illustrations in Florent Fels' *Propos d'Artistes*, published by La Renaissance du Livre, Paris, 1925, and dedicated to the painter Maurice de Vlaminck, himself pictured as a tough guy in a tweed suit – Man Ray

again.) Duchamp, often photographed, liked to appear as a specialist deep and even lost in thought. Marcel Broodthaers in the 1960s preferred, it seems, to be taken in action, en route, smoking or conversing. The thing about being an artist is that you are less important in yourself than as a producer. In Sinclair's series there are several such producer-artists, most notably Josef Herman, one of the most European of all British painters. Herman has allowed himself to be photographed in the presence of one his own paintings and backed by a set of African masks. He seems crowded from both sides, imposed on by powerful traditions. Euan Uglow also features as an artist-producer, backed by some of the tools of his trade mistily registered against the wall of his studio: a spirit-level, a set-square, a ruler, a classical mask and a clock standing at ten to twelve. Uglow looks back impersonally, knowing that his appearing in a photograph makes no difference in his particular world of art.

There are some actors among their number: the wonderful Gilbert and George, most especially, as waxworks, store managers or emeritus gallery directors. Someone on the set – either Sinclair or one of the principals – has managed the side-lighting to obscure one of the suits. Are they identical? Probably not, despite first impressions. As if it mattered, but it seems to, quite as much as Paolozzi's ball of string. Gilbert and George are anachronistic; no-one else does out-and-out acting these days. Kenneth Armitage does, however, and most poignantly. He appears, at first glance, to have taken himself off to a small courtyard behind his house, perhaps for the sake of daylight and to be in the company of some of his sculpted figures. He stands with his eyes downcast, demurely and reflectively, perhaps loooking back over a long career in the arts. Anyone at all might fold his arms across his chest, but in this case he seems to be repeating the gesture of a figure partly concealed in a niche behind him – a figure of a woman probably, to judge from the surface. It is, of course, not any gesture but that of a Cycladic figure. As a sculptor it must have been a gesture remembered and implanted from his earliest days. What does it mean? It seems to have allowed Cycladic artists to reflect on the distinction between men and women. The original figures were also grave goods, although now to be found upright in display cases in all of the world's major museums.

We judge figurative art by well-established criteria. We have any number of examples to go on (Arikha to Velázquez), and a figurative artist is likely to have been trained in figure drawing. Auerbach, Uglow and Ward will know more or less if the painting is

worthwhile, and that it can stand alone. We would only ask about the painter as an afterthought, out of idle curiosity or politeness. But not all art is so readily judged. There are specialists who will speak to you with absolute conviction about the merits and otherwise of certain abstract painters. Nevertheless, painters such as Howard Hodgkin and William Turnbull run risks. They are practising in an area where there are no readily available criteria, where willpower matters. It takes a certain amount of nerve, and trust in innate capacity to volunteer oneself as an artist in these circumstances. One result is that artists working under these terms become interesting in and for themselves. They have wagered on their aesthetics, and we wonder who exactly they might be. Hodgkin, for example, explains himself in interviews, remarking on the time it takes him to make judgements about his own paintings. He keeps them under consideration for months and maybe even years until he comes to a conclusion or final sense of their rightness. It is less, that is, the making of the painting which matters than its assessment. A figurative artist, by contrast, might work largely from a preconception, some throwing out in imagination of the design which is then realised in practice, through labour – like the building of a ship, say, or a house from a set of plans. If a figurative painting, such as Auerbach's landscape with trees, belongs to the history of landscape painting, a large abstract canvas by William Turnbull is forever the artist's own, associable with his own sense of how things ought to be or are. The artist has gambled, probably confident of success but at the same time running the risk of failure. Any artist working under these terms of reference can be understood as a tragic figure, as a solitary who has chosen to break with tradition, to forego some of its comforts.

The *Ecce Homo* style, excellently exemplified by William Turnbull, was originally the style of the 1940s and 1950s – Beckett and Piaf call it existential. But it ought to be thought of as the style and the predicament of the whole of the late modern and post-modern era. To be an artist then and now was to make a wager with contemporaneity – this, of course, is to exclude many of the painters and traditional artists. Innovate and see what happens. If you are thoroughly in tune with your moment the work or gesture is sure to be recognised, although, of course, it might be misrepresented and hyped. A lot of the debate around contemporary art involves the possibility that publicity has been substituted for novelty, that the genuine gesture has been falsified. Either way any contemporary artist stands to lose. To succeed absolutely means being thoroughly engrossed in and by contemporary culture, to the extent that one is used up by it and left

desolate when the tide turns. It is not inevitable, but it is likely. Either that or one is oversold and sooner or later put up as a target for critics and pundits. Any contemporary artist working in the public domain runs risks galore, not least that of being co-opted into the great rags to riches curatorial drama, art's contribution to popular entertainment. This explains why Nicholas Sinclair has photographed many of the younger artists in his series as solitaries, in some kind of relationship to their art but in general unsupported by the tools of their trade.

This is only one possible diagnosis of the artist in contemporary culture: a pilgrim on the *via terrena*, subject to all kinds of dangers and rewards. There are alternative understandings which downplay the role of the art world. We can easily think of art as existing in a culture apart, subject to the influence of Marcel Duchamp. Young artists, schooled in the ways of Duchamp, resort to tactics devised in the 1920s; or so the story goes. Anyone aware of the situation knows that art's contemporary dynamics are quite different. One of Sinclair's studies is of Adam Chodzko, an artist in his late-twenties, backed, in this case, by a plywood wall on which a tagger has put down a signature: 'KNOWN ...', it seems to read, although partly obscured by the artist's shoulders. What could be more natural than that a Young British Artist should be associated with a tag, the epitome of vernacular self-expression? You might take it as nothing more than astute scene-setting, but tagging is also a sign of the popular unconscious, of a widespread will to art and to self-expression. We may think of it conventionally in terms of social exclusion and vandalism, but it is also an index of social mobility and unbiddable, unsupervised energy – maybe in the style of the tracks left by animals in a hunting culture. This is one reason why London matters so much in the contemporary art world, because it is in London's labyrinth that these force lines can be most easily sensed.

But Sinclair is not a sociologist, nor interested in the anthropology of New Art. His commitment, apparent throughout this series, is to the depth model, to an idea of the artist as an individual harbouring secrets, even if they are secrets of his own investment. Kenneth Armitage making his complex references to Cycladic mortuary figures is the most thorough-going example of this, but the tendency resurfaces throughout. Antony Gormley, author of *The Angel of the North*, appears in a working outfit amongst an ensemble of his own creations, one of which reaches upwards, suspended maybe in the style of a martyr or of Marysas, the victim of Apollo. And then in the far corner of the

room what seems to be a stuffed and stitched animal, but more like Icarus come to grief, feet uppermost on dry land. What could be more appropriate, though, than that the inventor of a gigantic and successful winged figure should choose to reflect on the fallen Icarus? It is a psychological portrait, and one which declares itself as such, virtually a tableau. Elsewhere the disquiet is more subtly expressed in the shape of events in the background. Richard Patterson placed between light and dark might be threatened by that stalking figure in the background. Anya Gallaccio seems to have moved or to have been asked to move to the right, the better to disclose what might be a negative of a tree in the background. This is one of the most remarkable pictures in the series, because it seems almost impossible to fathom. She has moved off line, you might almost imagine, to avoid the camera, as if she in particular had some sense of its power to disclose – the 'negative' figure in the background looks almost like an X-ray. Laura Godfrey-Isaacs also seems to have been asked to move just somewhat to her right, the better to take advantage of a darkened surface in the background. It may be a painted surface but it looks like a door onto some kind of mystery better kept out of sight. Perhaps Sinclair took his cue from Richard Hamilton, one of the most photogenic of subjects, who has been presented in front of a large-scale self-portrait unevenly divided between light and darkness, as if the two zones were in conflict.

It was Hamilton, of course, with his version of *The Large Glass*, who is supposed to have introduced the Duchampian strain into British art. Maybe so, but there is very little evidence of it here. The nearest to a Duchampian detail is that ethereal tree of life growing out of the light on Anya Gallaccio's shoulder. Otherwise we are in an art world virtually unfathomable with respect to lineages and styles. Yet in some odd way it does cohere, and might be thought of even as a family. All those who have been through British art schools will remember what they were like: clan systems, with septs: modernisers, post-modernisers, glamorous visitors, legendary external examiners, believers in life drawing, colourists, fetishists, miniaturists, survivors from other art worlds lost in the mists of time. By now most of them have been aesthetically cleansed of all those old believers who refused to co-operate. This, Sinclair's imaginary family, must be seen as a glorious coda to that way of life, all staged as a fable or as the tragi-comedy which it always was.

The Photographs

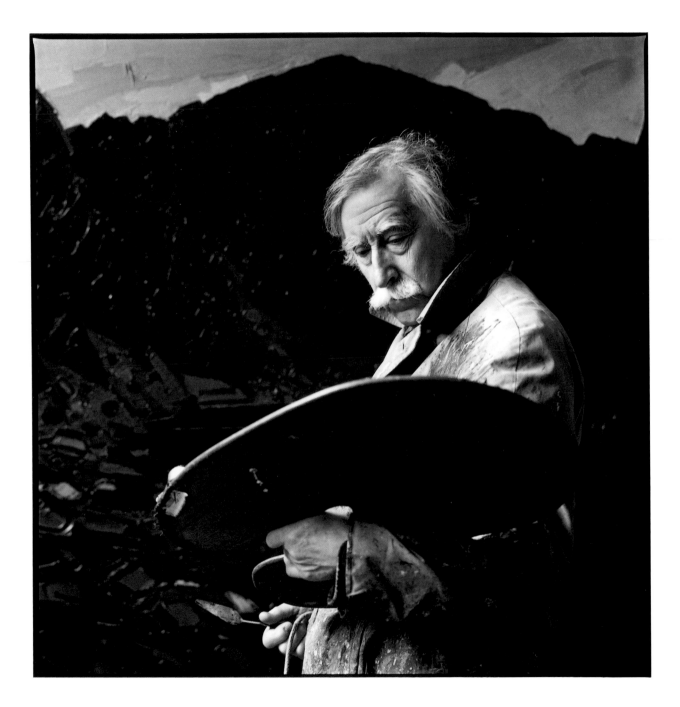

Sir Kyffin Williams

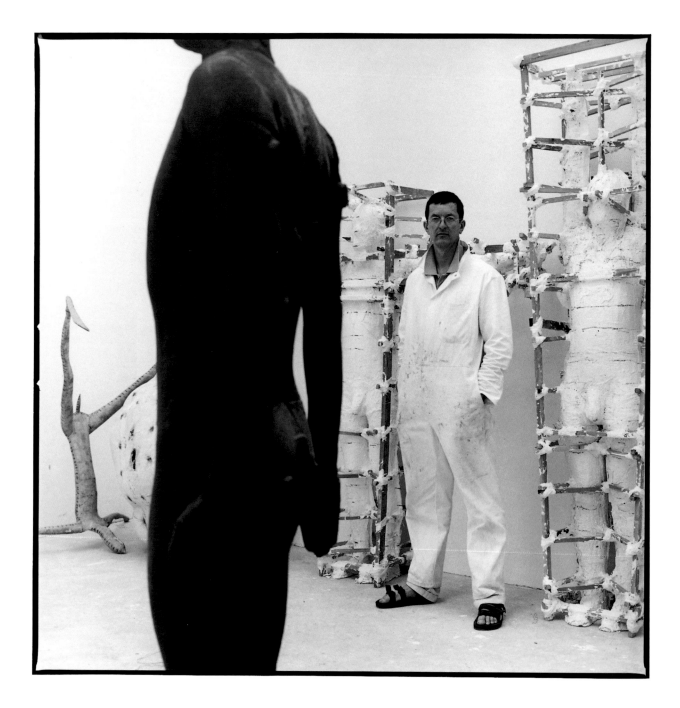

Antony Gormley

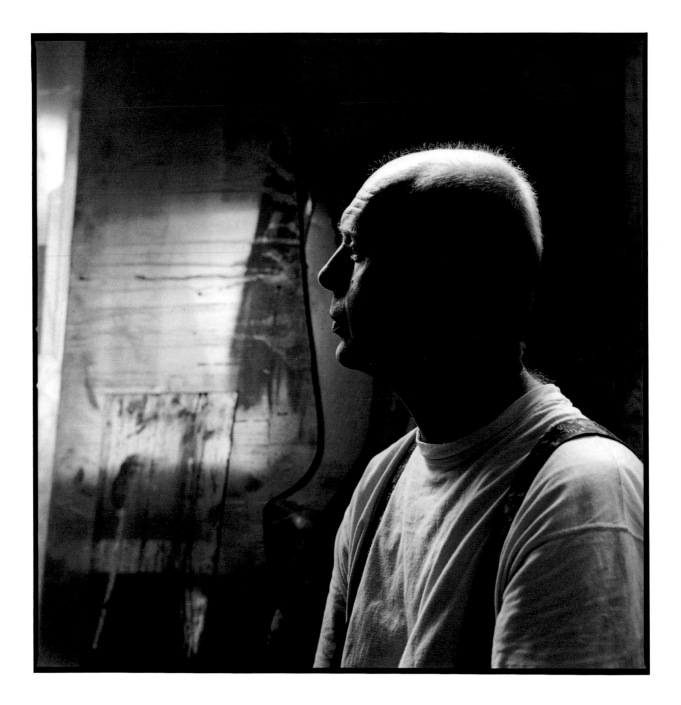

Richard Deacon

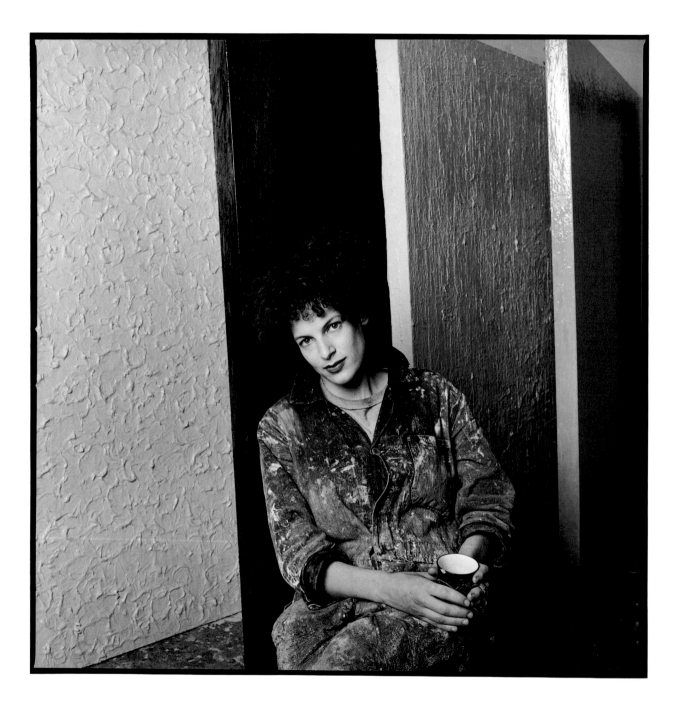

Laura Godfrey-Isaacs

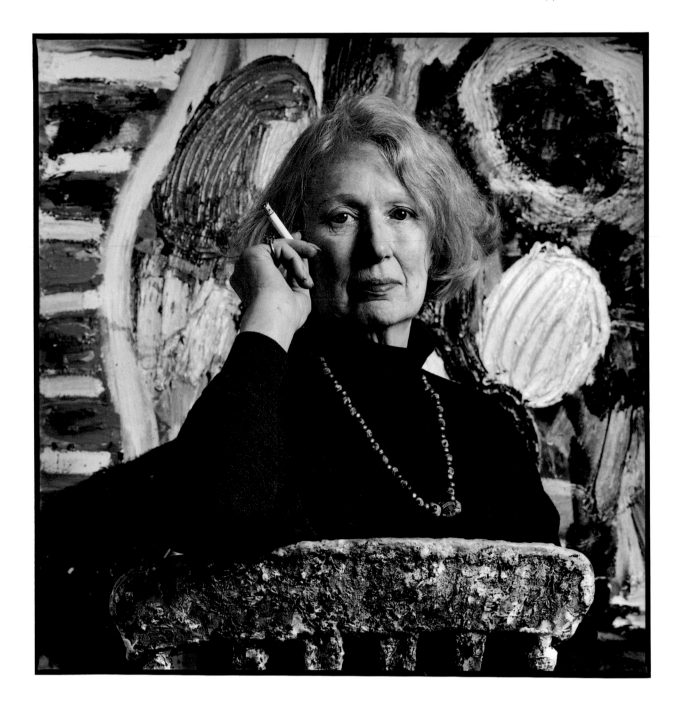

Gillian Ayres

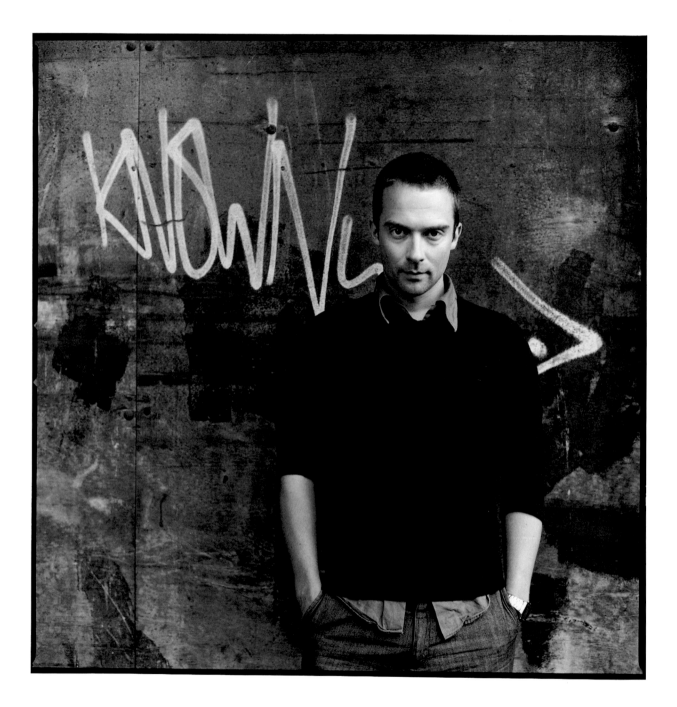

Adam Chodzko

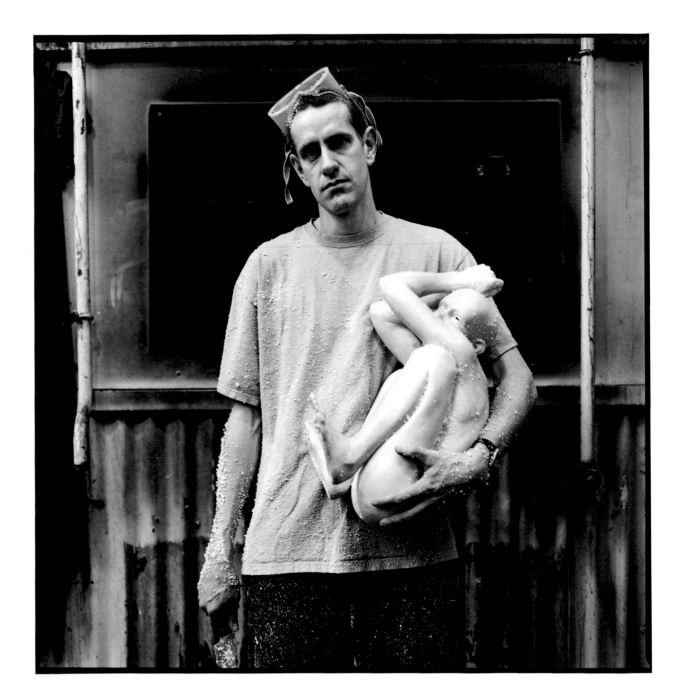

Ron Mueck

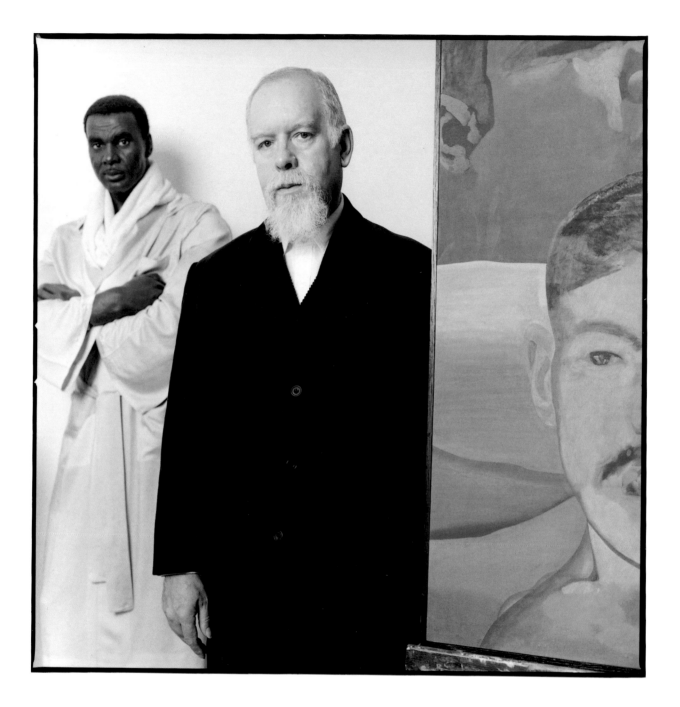

Peter Blake

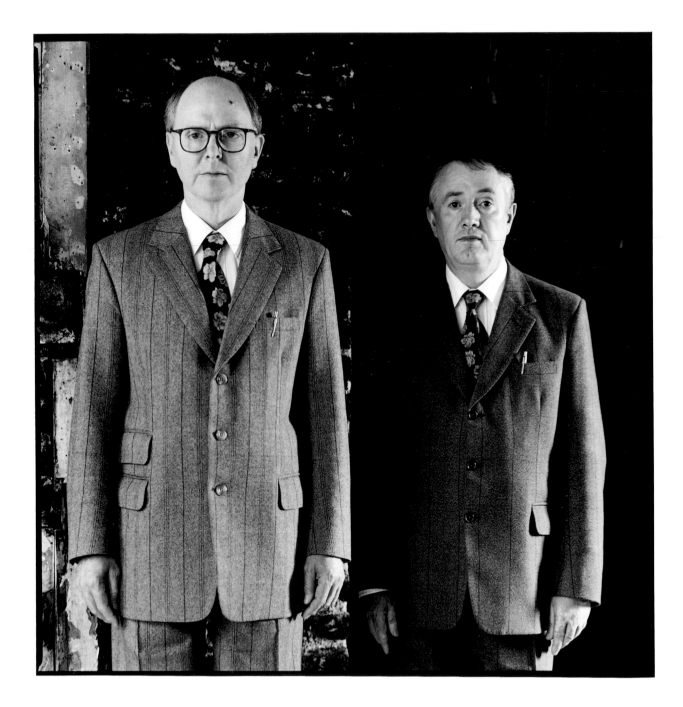

Gilbert and George

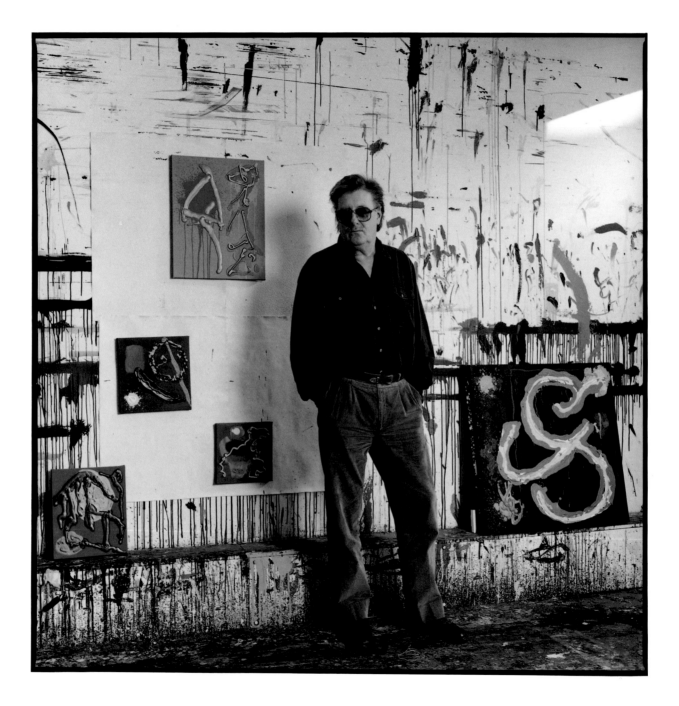

John Hoyland

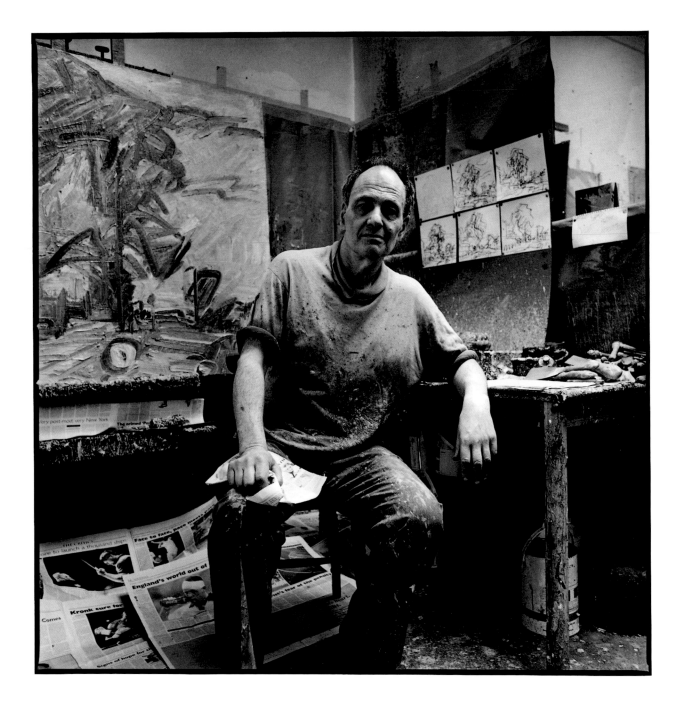

Frank Auerbach

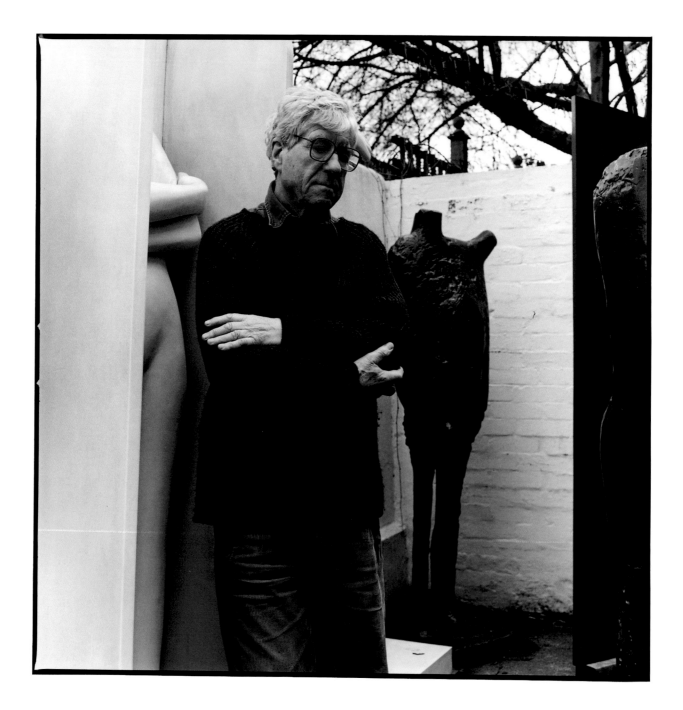

Kenneth Armitage

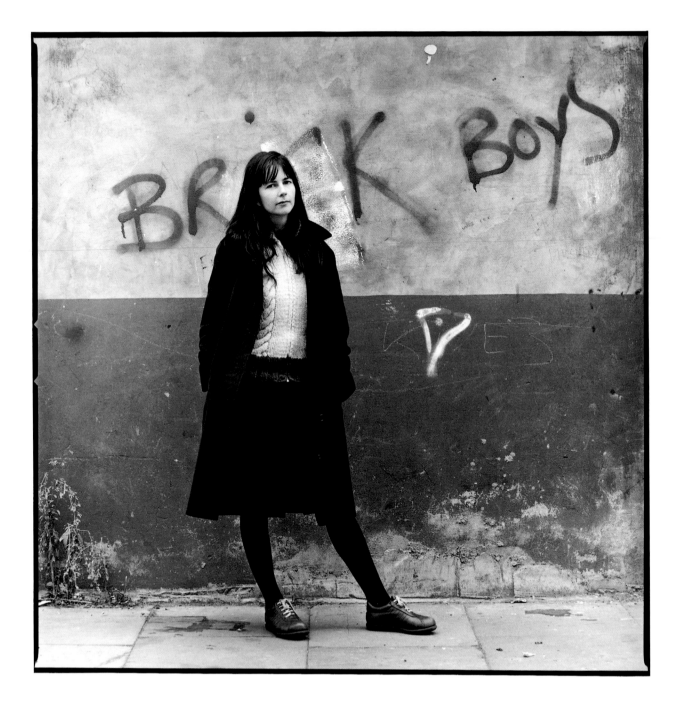

Gillian Wearing

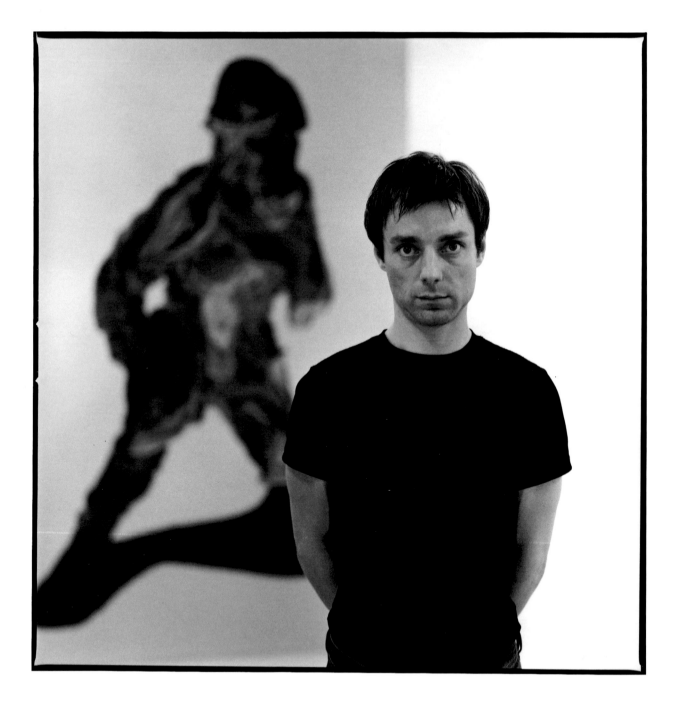

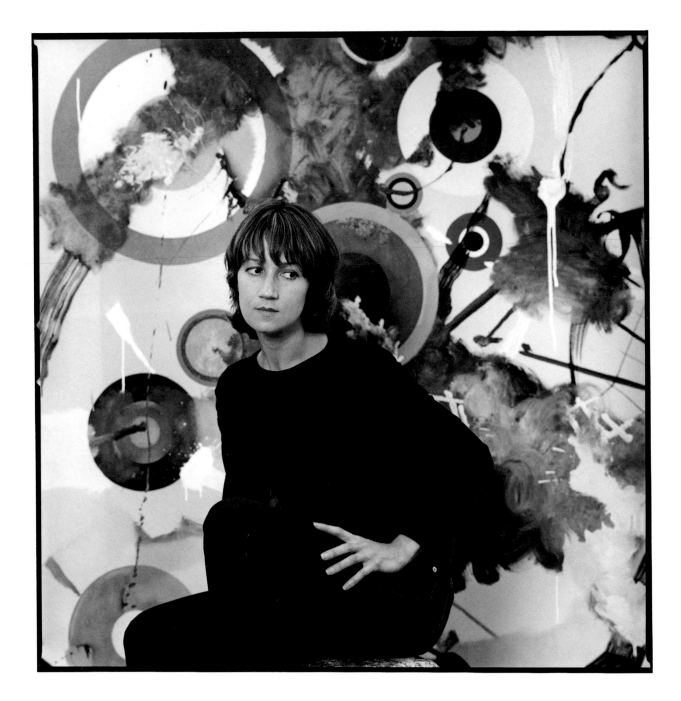

Fiona Rae

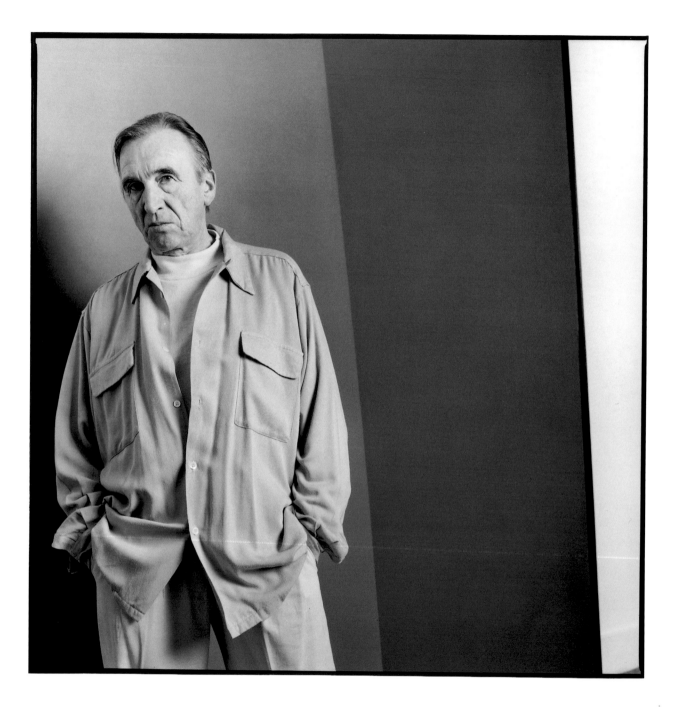

William Turnbull

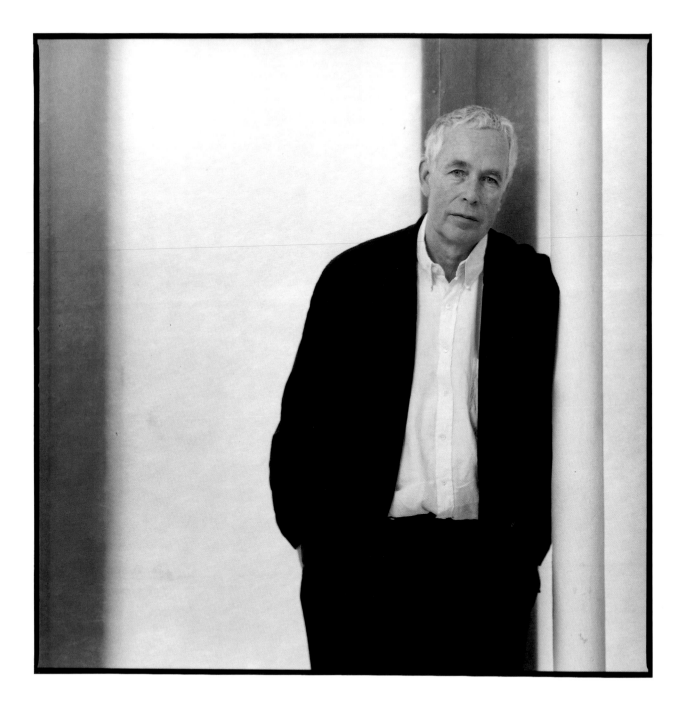

Sir Howard Hodgkin

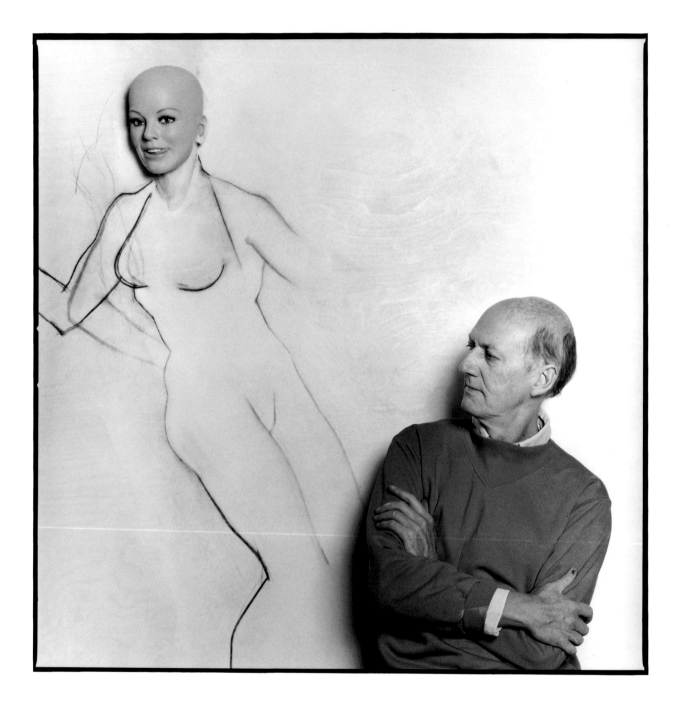

Allen Jones

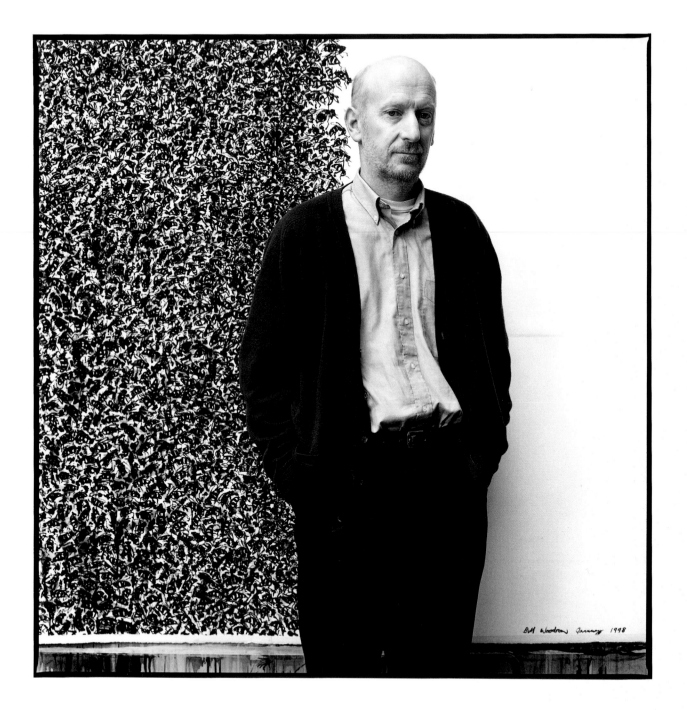

Bill Woodrow

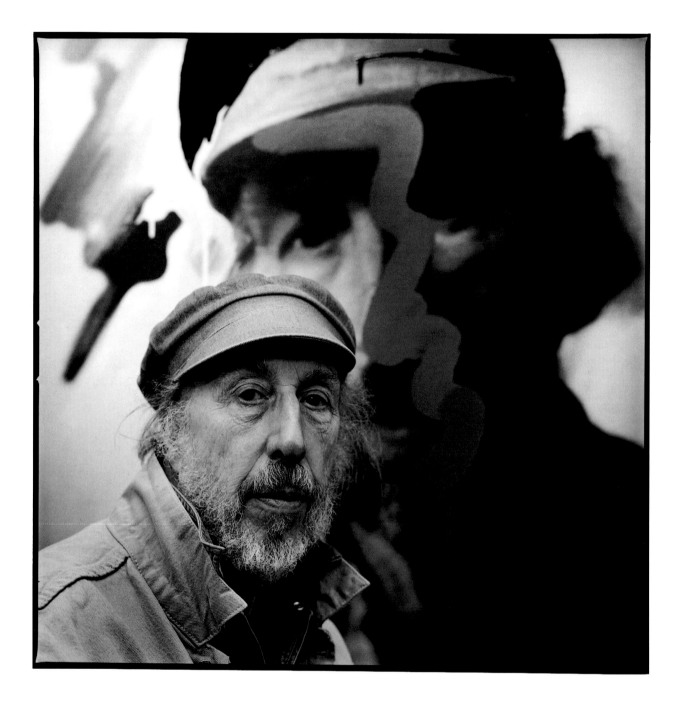

Richard Hamilton

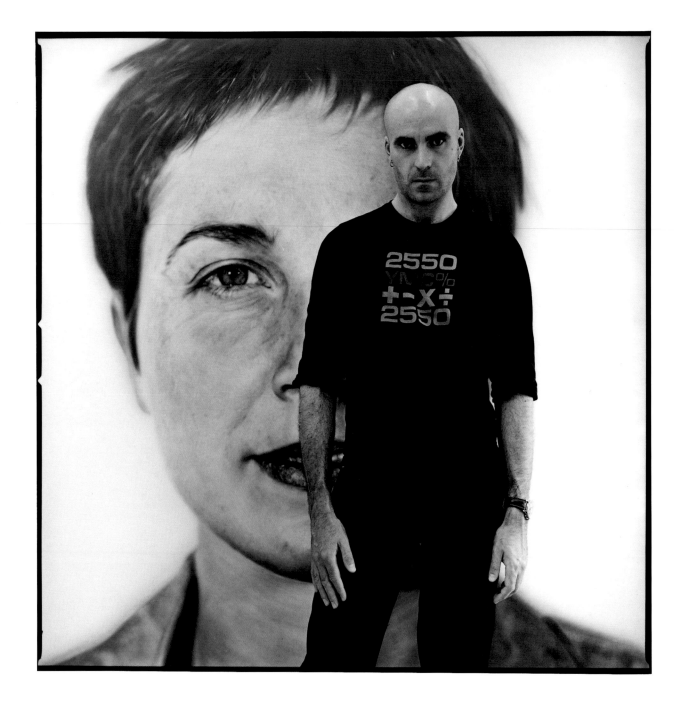

Jason Brooks

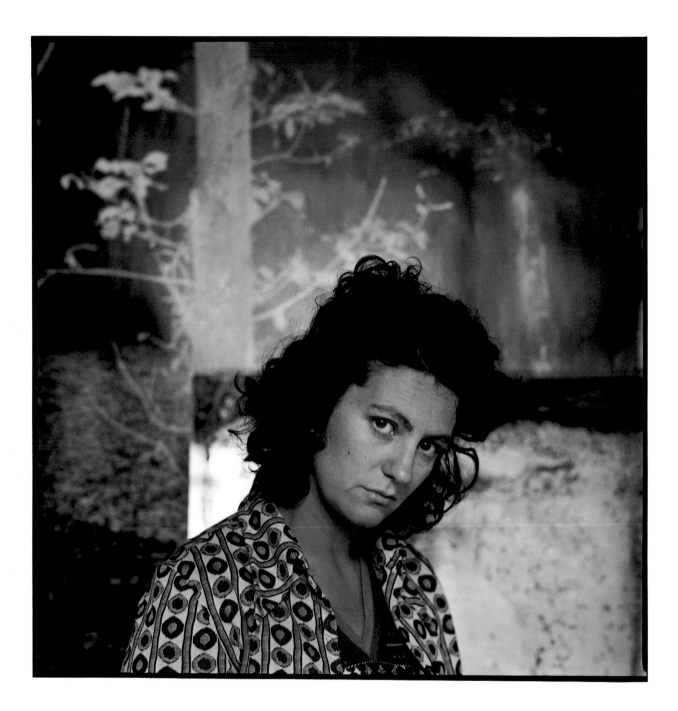

Anya Gallaccio

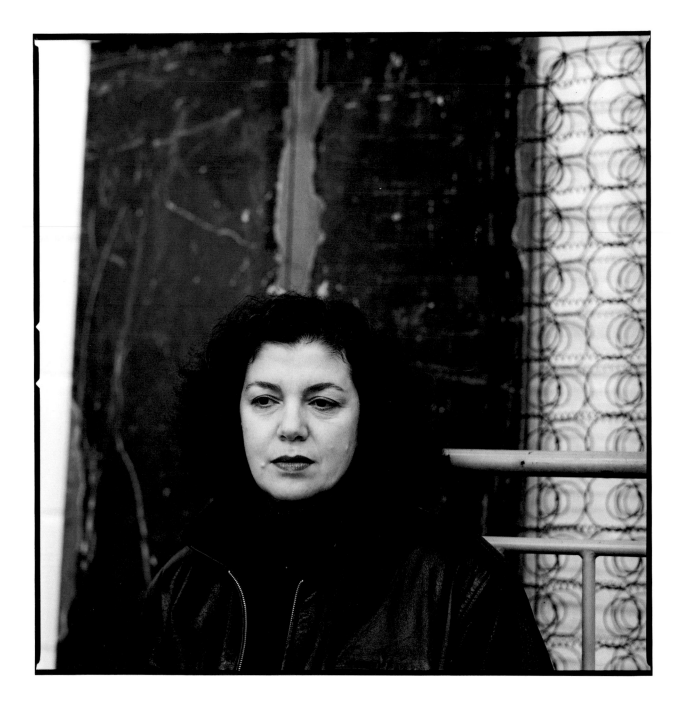

Mona Hatoum

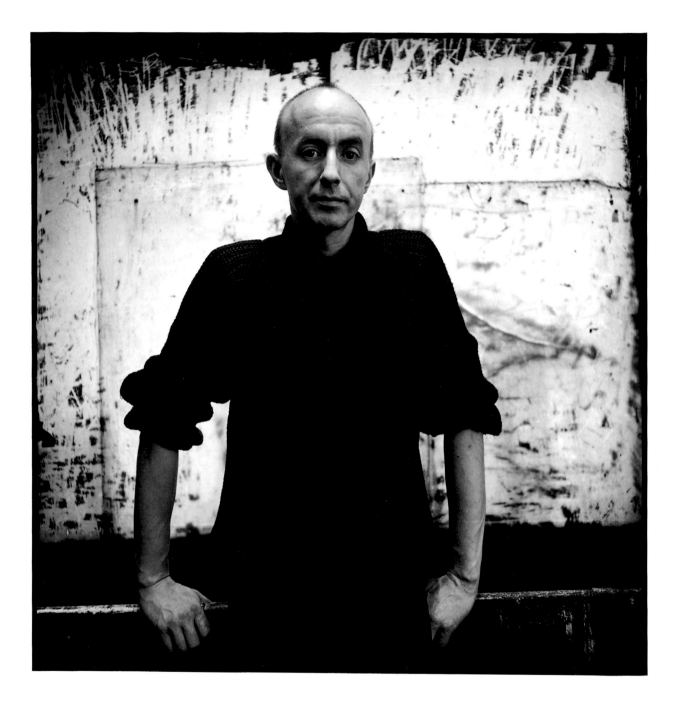

Grenville Davey

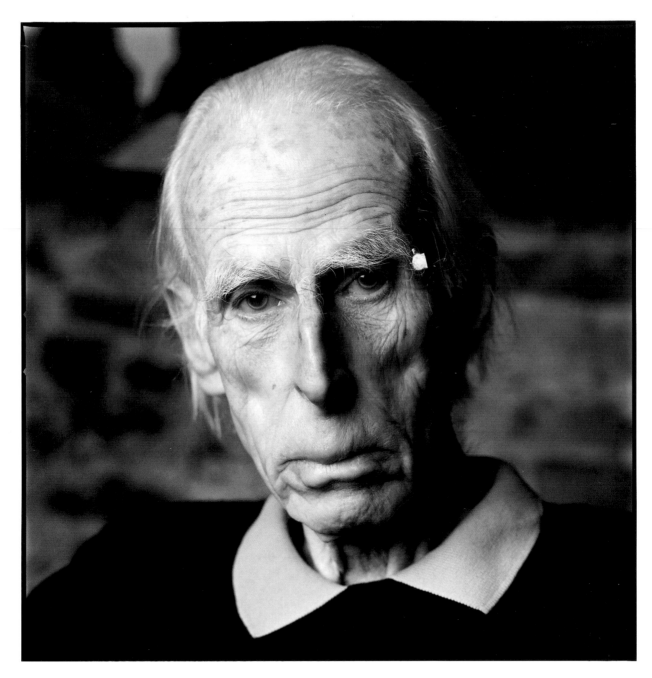

John Piper

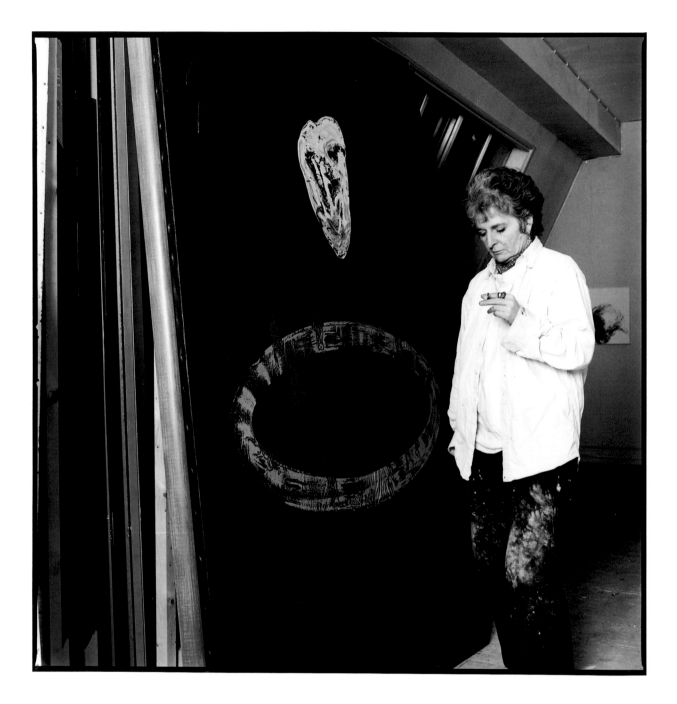

Maggi Hambling

Adrian Berg

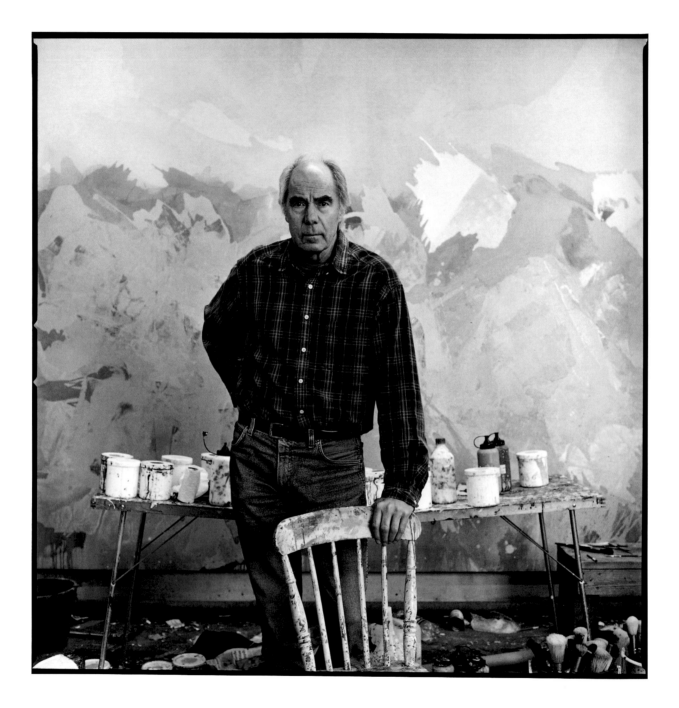

Albert Irvin

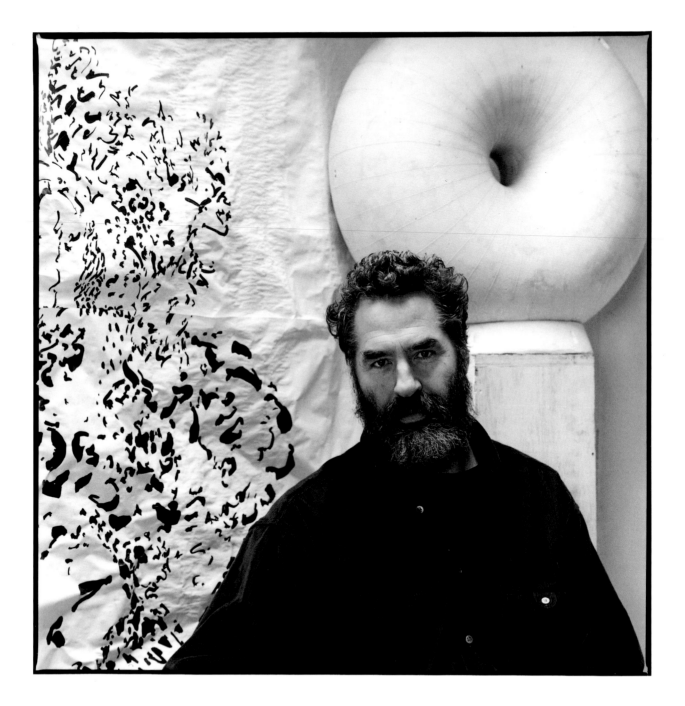

Hamish Black

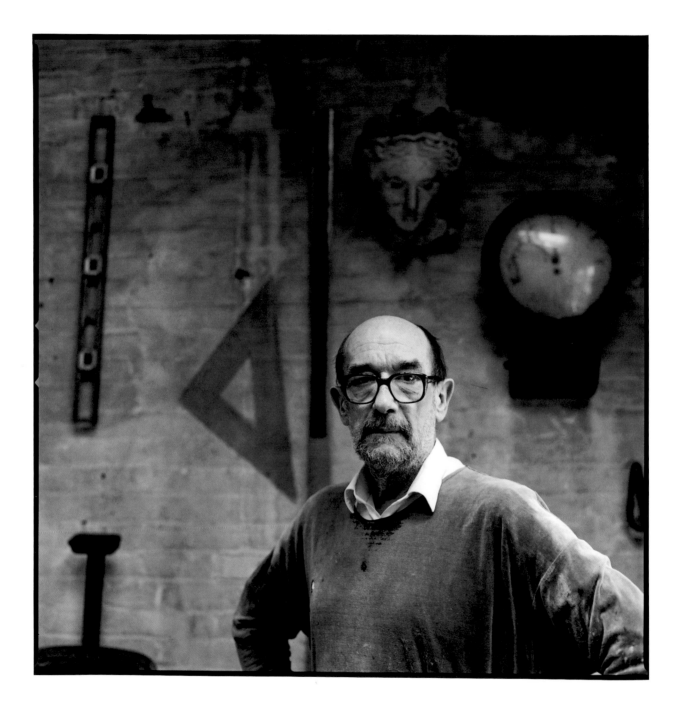

Euan Uglow

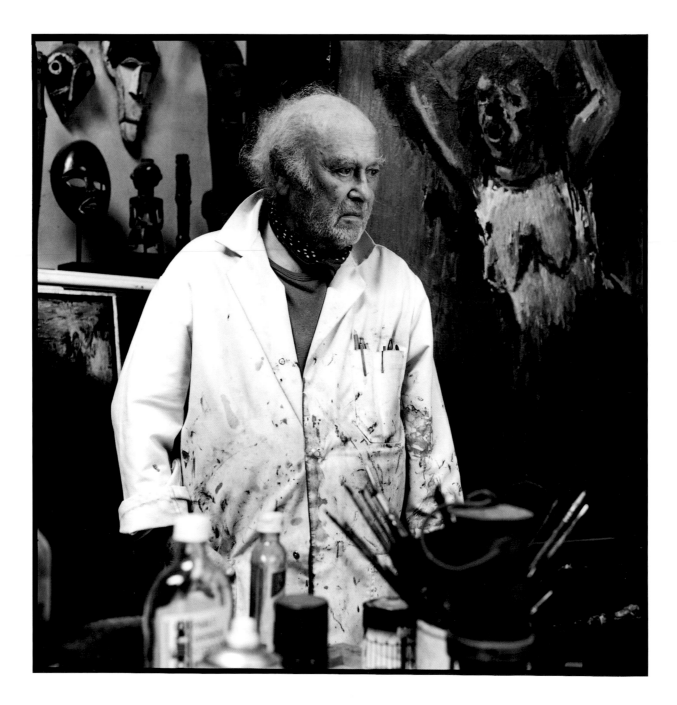

Josef Herman

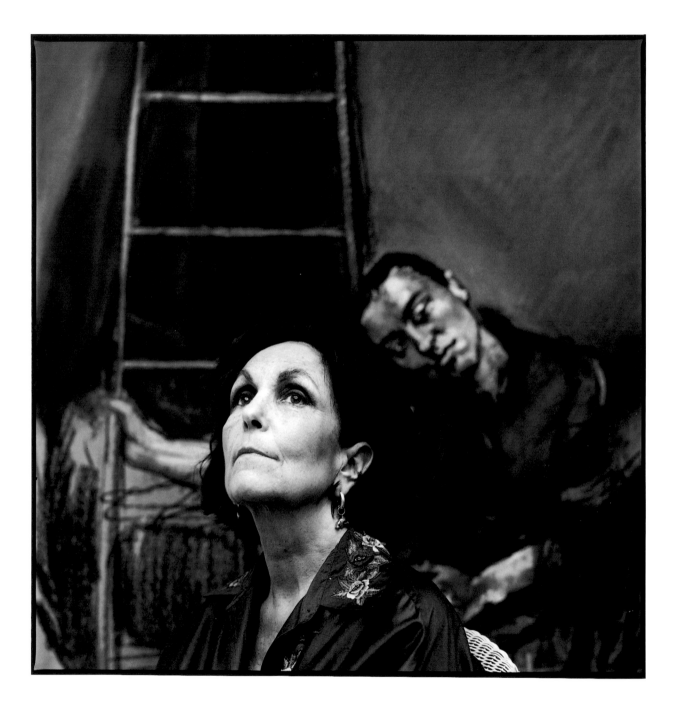

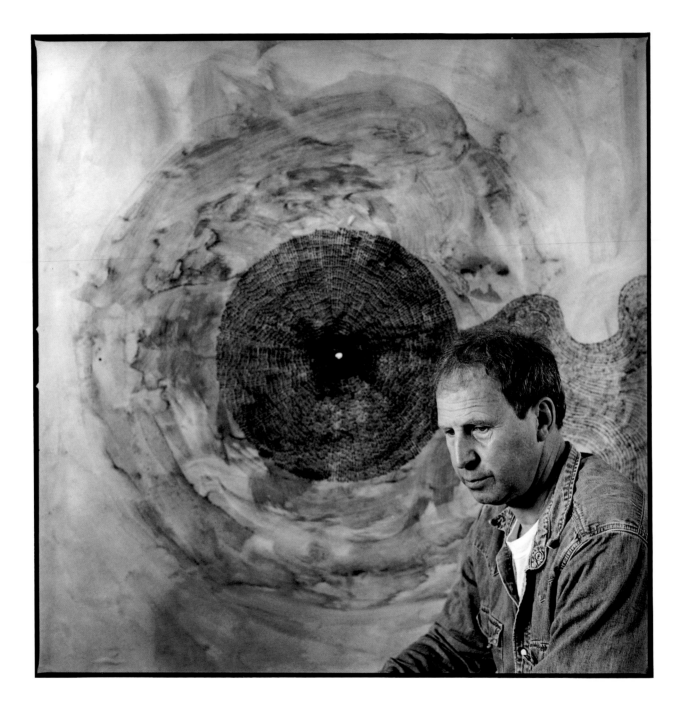

Chris Drury

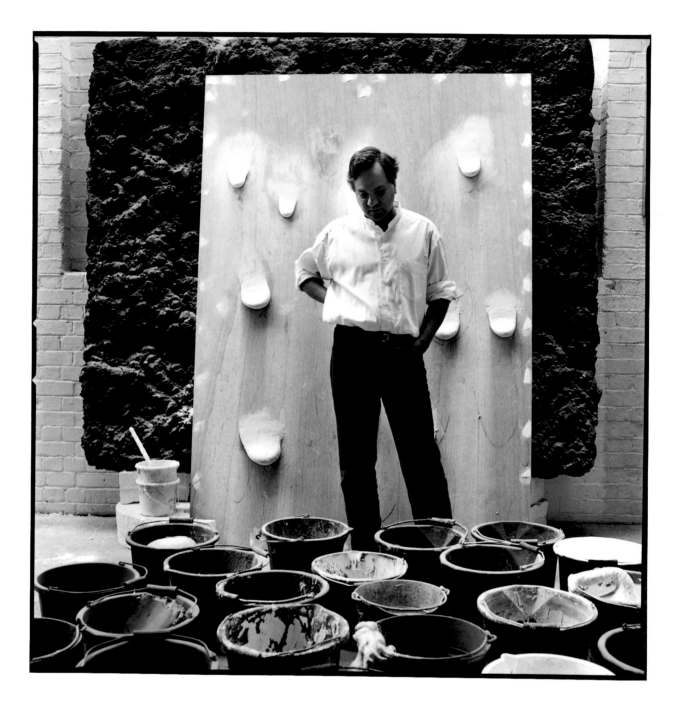

Anish Kapoor

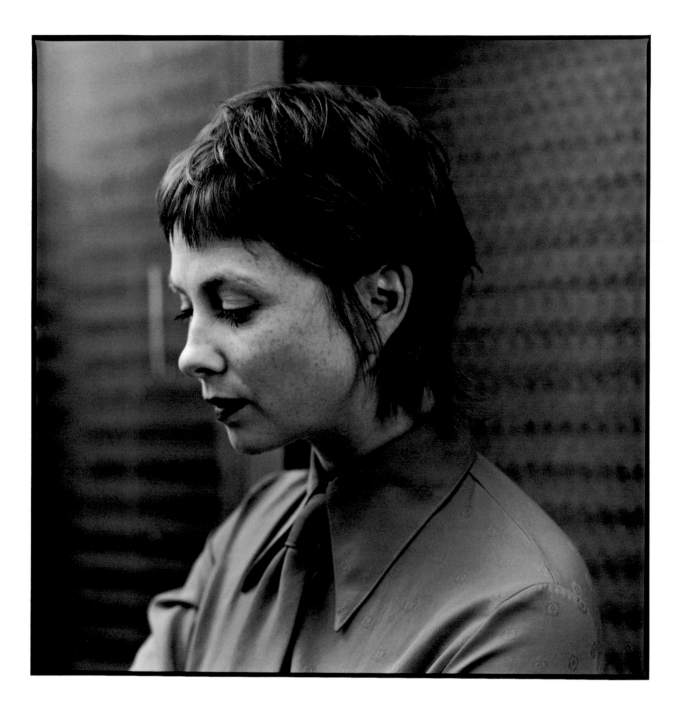

Georgina Starr

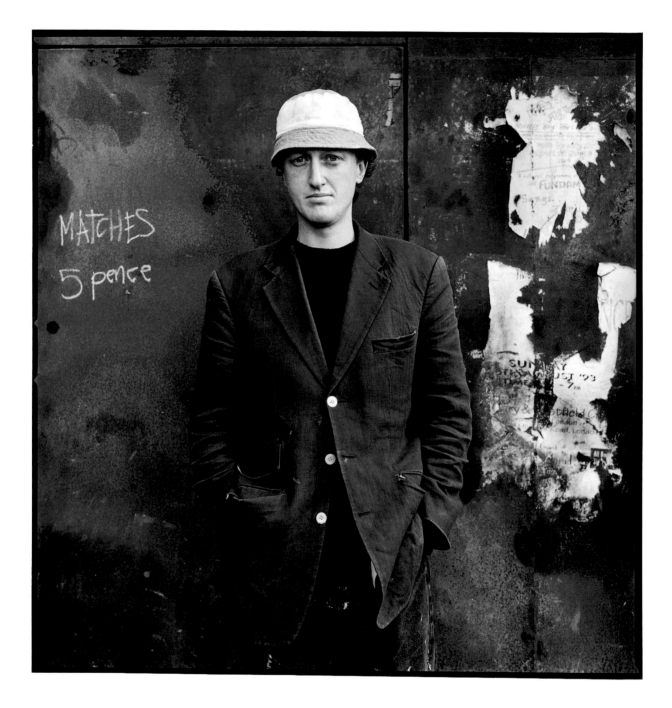

MATCHES
5 pence

Michael Landy

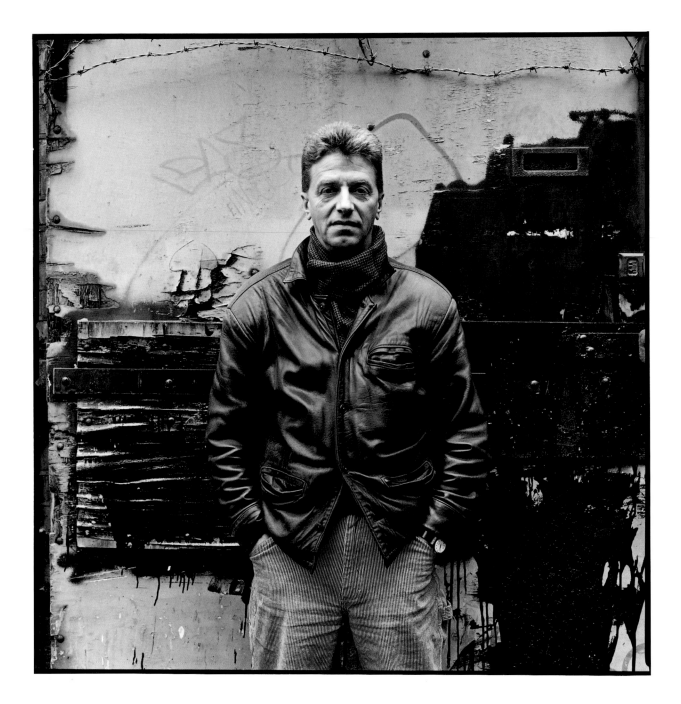

Edward Allington

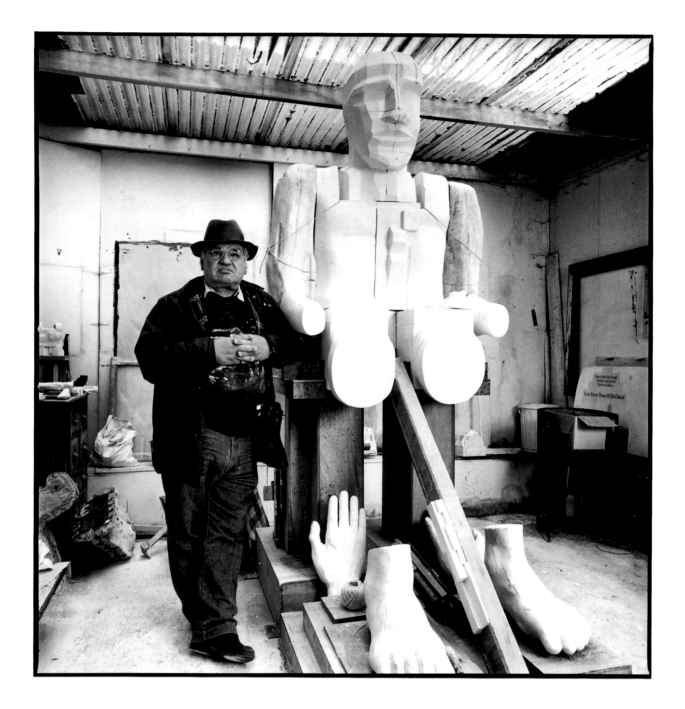

54 Sir Eduardo Paolozzi

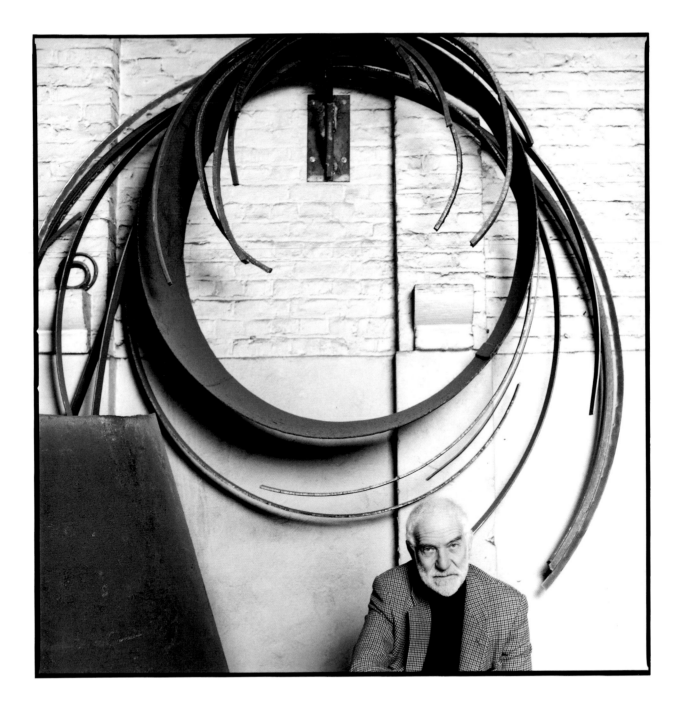

Sir Anthony Caro

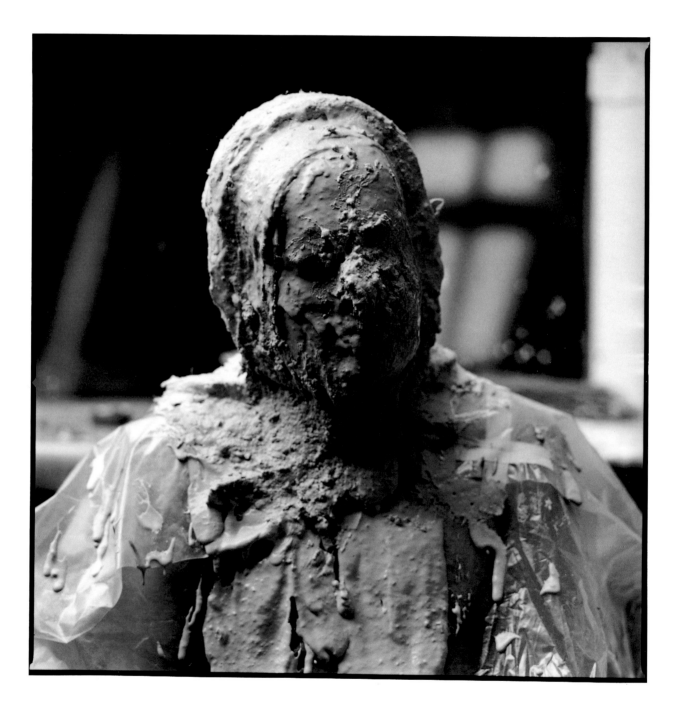

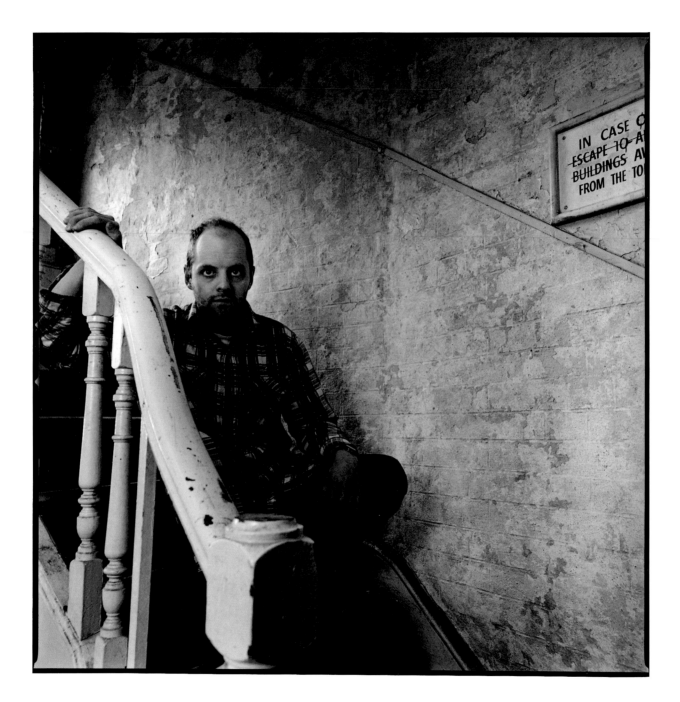

Gavin Turk

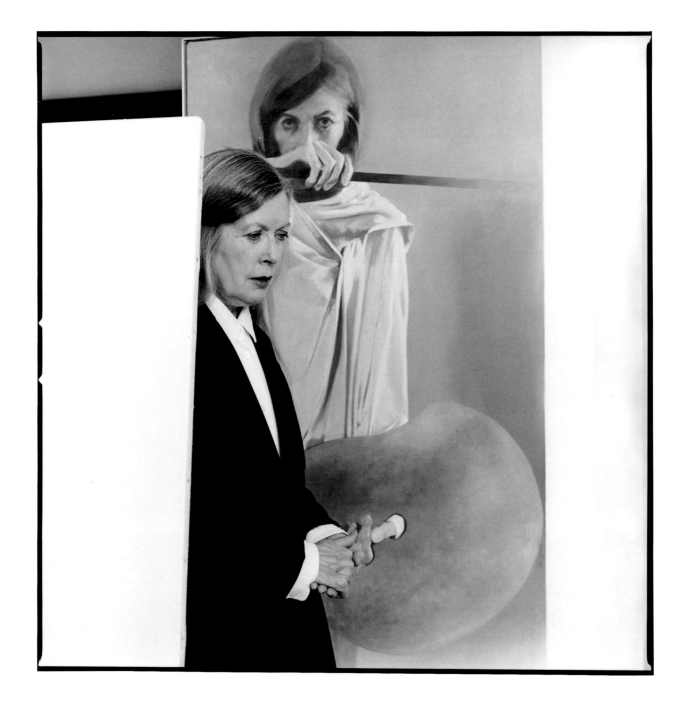

Rita Donagh

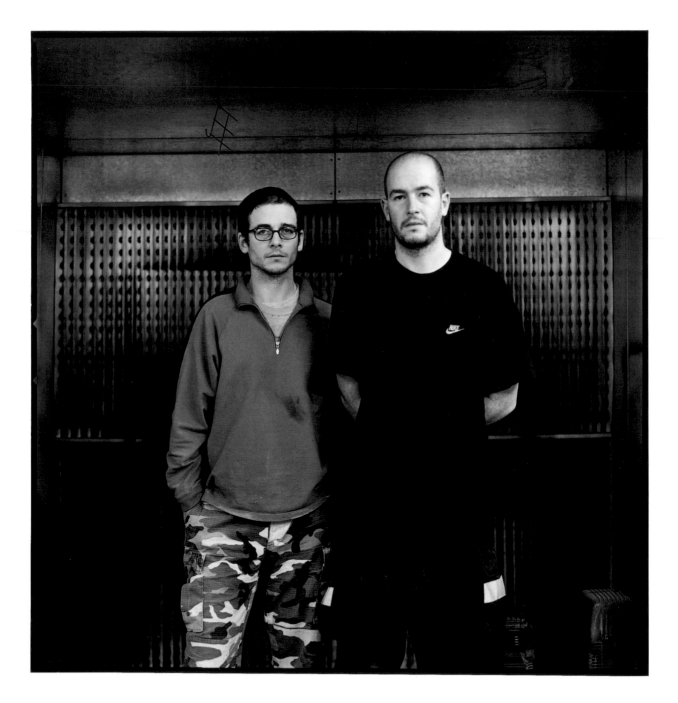

Dinos and Jake Chapman

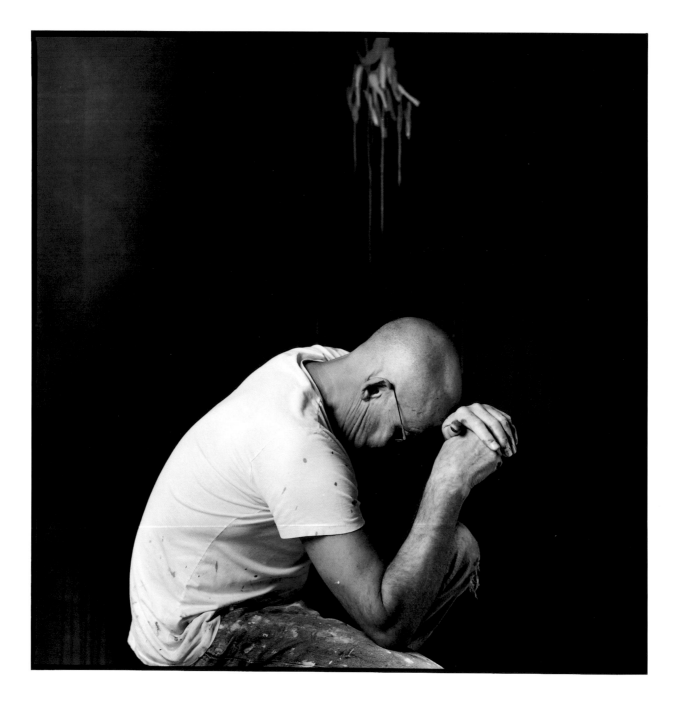

Robyn Denny

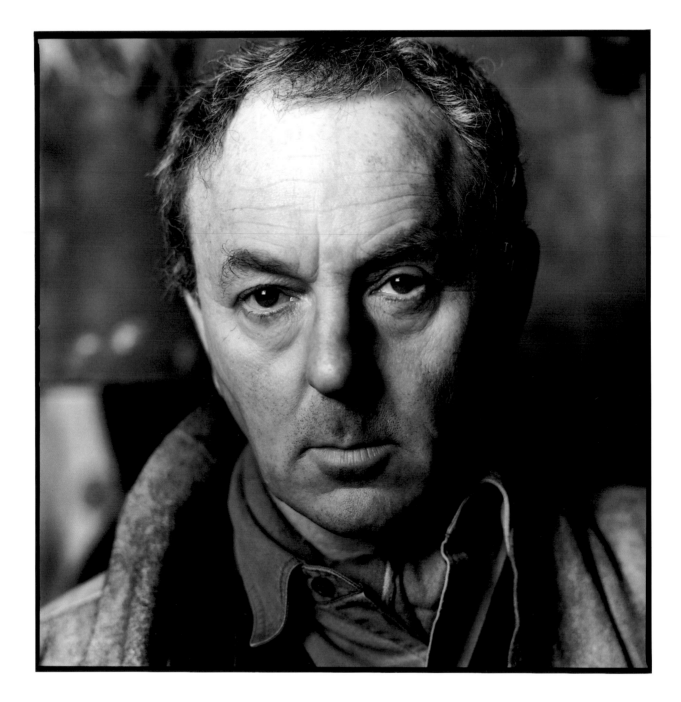

Gerald Laing

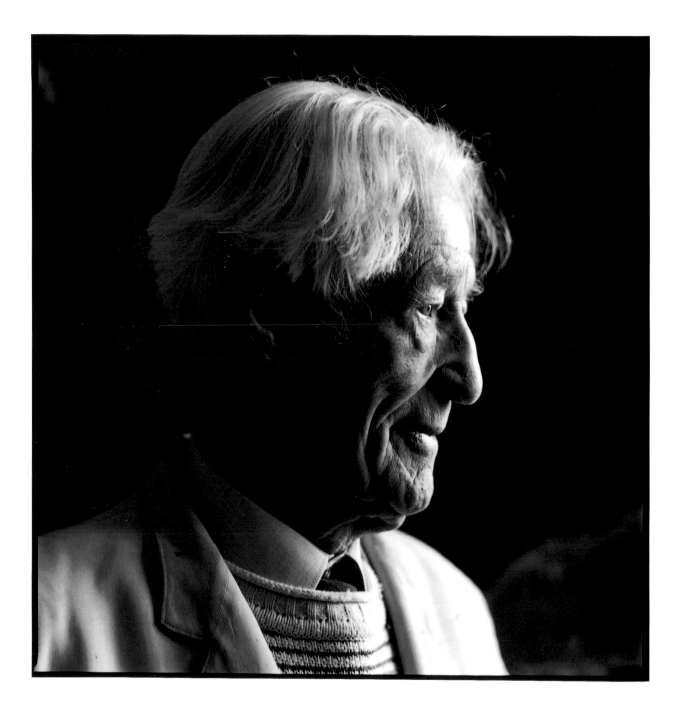

Will Roberts

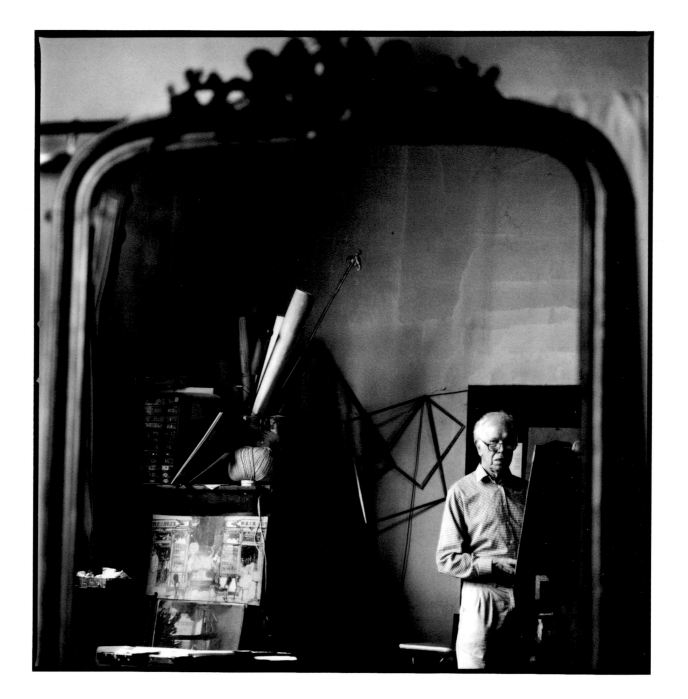

John Ward

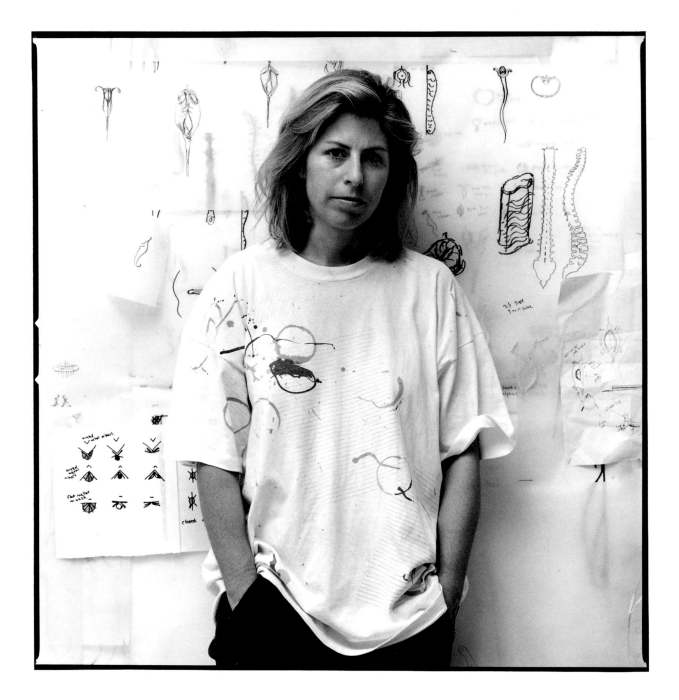

Cathy de Monchaux

Nicholas Sinclair in conversation with Robin Dance

Robin Dance It's clear that these photographs are the result of a collaboration between you and the artists. You couldn't have known – you didn't, I understand, have the luxury of being able to discover in advance – the exact physical circumstances, let alone the other circumstances, emotional, psychological or logistical, which formed the context of your meeting with the artist. I imagine that the degree of collaboration will have varied considerably from one artist to the next, with impatience and reluctance at one end of the spectrum, and active, empathetic collaboration at the other. Did any of the artists try to take over the proceedings, to control or manipulate the outcome to their own advantage?

Nicholas Sinclair No, none of the artists tried to take control. There were one or two occasions when an artist suggested a suitable background; for example, Fiona Rae was keen for certain unfinished paintings not to be included in her portrait. Artists would suggest things, and obviously at one level they had some control over what developed because we were working in their studios rather than in mine, studios which they themselves have created. But the final composition, the actual arrangement of the artist within the square frame, was always my choice.

RD Did you in any way predetermine the portraits, or was it all a matter of improvisation?

NS It's like so much of what one does in photography. You go out with an aim, an idea, and of course a will to make something worthwhile occur, but finally it's a case of responding to what is actually there and the constraints that go with it. Then it's a matter of assessing what has happened, by looking at Polaroids while working on location and, later, back in the studio, analysing the contact sheets and assessing them to see if something of value has occurred, to see if there is a connection between your memory of the person photographed and what you see on the contacts.

RD Did you know the artists' work before meeting them?

NS Yes, I always made sure that I knew their work, and I also had some idea, from previously published photographs, of what some of the artists looked like. But there is always a difference between the way other photographers have made portraits of artists and the way that I work, so there can be an element of surprise when you meet the artist for the first time and discover a person quite different from the one you were expecting.

RD Is it the case then, to quote Francis Bacon, in his discussion with David Sylvester about the part that chance or accident played in his painting, that 'the will has been subdued by the instinct'?[1] That you have been willing to put aside any predetermined ideas and to allow something quite unexpected to develop, that, if you like, you have set out with a map and a route-plan but that you have been ready to wander off course if something else attracted your attention?

NS Yes, it's a question of responding to circumstances, to what you actually find. I rely very heavily on intuition and improvisation, and on experience – of knowing what will and will not work in a photograph. Every photographer knows, or should know, that there can be a gap between intention and outcome, that for much of the time the thing you are consciously trying to do simply doesn't work. But as you become more experienced, that gap narrows, and you attain a kind of fluency.

RD What exactly do you mean by fluency?

NS I mean a continuous, uninterrupted flow of connections between all of the feelings, thoughts, questions, responses and physical actions which go into taking a photograph. It begins with intuition – that moment when I believe that something is going to work photographically – which is then followed by a series of questions: how will the three-dimensional reality in front of the camera translate onto the ground-glass screen? What will happen when the arrangement of tones, seen with the eye in colour, is transformed

into black-and-white? In other words, is this three-dimensional, colour situation going to translate onto a two-dimensional monochrome surface? Then there are technical considerations, in particular the ability to make decisions about aperture and shutter speed settings, and about lighting. Is the light adequate, or will I need additional light? Finally comes a decision about critical plain of focus – how much of what I see through the viewfinder, under the given conditions, can I bring, or do I wish to bring, into sharp focus?

RD And all that has to happen within a very short space of time.

NS Yes. After all, I only had an hour or, at most, two hours, to work with the majority of artists, and in some cases, much less time.

RD Is that a disadvantage, the lack of time in which to make a portrait?

NS Yes, you do need time to make a portrait. There is the argument that shortage of time focuses creative energy but I always make better portraits when I am given time. The key thing is to approach the situation in the right frame of mind, in a state of relaxed alertness, which will also make the person you are photographing feel more at ease. I trust my intuition and, at the same time, I rely on certain well-established methods. You'll see in this series there are techniques I use over and over again, techniques which not only help to give the overall body of work a degree of visual consistency, but also provide a certain structure, a kind of working framework which, when you are under pressure, frees the mind and the eye to respond instinctively.

RD Can you give me some examples?

NS When searching for particular locations in which to photograph the artists I very often look for flat surfaces – I use flat backdrops in portraits more often than three-dimensional backgrounds – for example in the portraits of Edward Allington, Robyn

Denny and Adam Chodzko. And throughout I use the same format, which I have been using for many years. Being completely familiar with the camera and the format is vital if you are to work fluently.

RD Your lighting also seems consistent. The lighting you have used is both restrained and 'democratic', in that it gives more or less even emphasis to all parts of the photograph, not just to the artist's face and body. Did you use daylight as well as artificial light, or a mixture of both, to achieve these results?

NS What I have done is to 're-create' in the final photograph the feel of the light which I found at each location, and to achieve this I use available light – for example, daylight from windows and skylights – but I sometimes mix it with electronic flash, which I either diffuse or bounce or reflect, to enhance the light. Certain artists, particularly the older artists who work in a more traditional way, such as Frank Auerbach, Josef Herman and Kyffin Williams, have chosen a working environment in which there is north light, the most even and consistent natural light with which you can work, and in those situations I've used the natural light. But there are other situations in which the lighting is poor, and in those situations I've added light, but in a way that it is hardly noticeable. I personally dislike the chiaroscuro effect you see in Bill Brandt's portraits, with their heavy, blocked-up shadows. Shadow detail in my photographs is important and so I light the subject and expose the film, and print the photograph, in ways which reveal this detail.

RD In discussing photographs, subject and background are often talked about as if they are separate entities. Whilst in this series there is clearly a well-defined subject in each case – the artist – it seems to me that rather than using the available physical contexts in each situation simply as formal compositional devices, as Brandt did in many of his portraits, you have used the whole of the frame to create a kind of continuum, in which you make a link between pictorial background and personal background, as a way of making a more substantial portrait of the individual.

NS Yes, this could be the case. In 1990 I photographed the actor Paul Scofield, and during our conversation I asked him why over such a long career he has been so selective about the parts that he has chosen to play. He explained that when offered a part he always looks for three things – firstly an inherent sense of truth in the script, secondly whether he, as an actor, has something he can bring to the part, and thirdly whether he can identify the internal landscape of the character he is being asked to play. It seems to me that the process he was describing is so close to the creative process in portraiture that it has always remained with me. It is when I feel a connection with the subject I am photographing, or with the subject's work or with their philosophy, that I can really bring something substantial to the image. So yes, background is critically important, and I'm using what I find in each situation, the artist together with the immediate surroundings, to make a portrait which works on a deeper level than one which simply says this is what a particular artist looked like at this time. And there are often discrete, peripheral details, which can be read as clues leading to a better understanding of the artists and their work. It's a question of using the surface to try and reveal something of the person. If the background is wrong, the whole thing fails. And here I must return again to the question of lighting, because it's obviously important that if everything within the frame has been carefully considered, then everything must also be lit in such a way as to give the various elements in the frame a chance to work together.

RD Something interesting which emerges from the series as a whole is the way in which the artists and their backgrounds – their working environments and their materials, and their actual work – in a curious way appear to resemble each other. There are, for example, qualitative similarities between Anthony Caro's taut, springy and precisely cut artist's materials hanging on the studio wall, and his neat, close-trimmed beard, crisp jacket and alert, focused expression. And, on the opposite page, between the solid, immovable figure of Eduardo Paolozzi and the massive, robotic sculpture against which he is leaning. The most extreme, and perhaps exceptional example, is your portrait of Marc Quinn, in which the artist appears to be actually in the process of becoming a work

of art – also true to some extent with Antony Gormley, and Gilbert and George, who long ago declared themselves to be 'living sculpture'.

NS With Marc Quinn, Antony Gormley and Gilbert and George, and to some extent Paolozzi, you've isolated the five artists in the book who work with their own body. One of the things I'm trying to show in this series is the process of working, to bring together the artist and the work, whatever that work might be, but in the late 1990s we're not just looking at artists working in traditional ways – with easel, canvas and oil paint, for example. Marc Quinn is in the process of making a cast from his own head, and Antony Gormley is, in his portrait, standing between two casts made from his own body. I've placed him there, rather than bringing him forward, to give a sense of scale, to show the direct relationship between the artist and the early stages of a piece of sculpture. With Caro, I first of all made a Polaroid of the background, which I had selected from a number of possibilities in his studio. I showed him the Polaroid and discussed it with him, and then asked him to crouch down into the position you see him in. One of the advantages of setting up backgrounds in advance means that I can concentrate on the person, and with the muscles around the eyes and the mouth capable of moving up to forty times per second, this way of working frees me to watch for subtle changes in facial expression.

RD But did all of the artists you photographed have studios in the traditional sense, particular places in which work actually gets made, places in which you could find this kind of informative background material?

NS No, in some cases, especially with the younger British artists, such as Gillian Wearing and Adam Chodzko, you're looking at artists who work with, for example, photography, video and film. Their studios, if they have them, might be more like an office space or a storeroom which, from my point of view, is uninteresting.

RD Unrevealing, perhaps?

NS Yes, I didn't feel I could say very much with what I found there – a computer, a phone or a fax machine.

RD So what did you do in these circumstances?

NS If the artist hadn't already proposed something which looked promising, I would look at the surrounding area, to see what I could find.

RD During the session with the artist?

NS No, I explored the area beforehand. It is worth pointing out that many of these artists' studios are in clusters, in certain parts of London, areas which are run-down but which are, sadly for the artists who are being forced to leave, being redeveloped. I would look at the general atmosphere of the area, and at the buildings, and sometimes discover connections between the physical nature of a building's surface, with its peeling paint or graffiti, and the social or political context out of which an artist is working.

RD There are other consistent aspects which bind the portraits into a cohesive whole, such as the way in which you have represented the artists as people who look serious and intelligent but who are also engaged in a physical act of making, of dealing not only with ideas but also with materials and technical processes. We know, of course, that great artists have been doing this for centuries, but it goes directly against contemporary popular notions, at least here in Britain, of the artist as a kind of naughty or outrageous joker or improviser who suddenly emerges as a star, and would also seem to bridge a gap in the popular imagination between the thinker – intellectual, academic, philosopher – and the maker – builder, engineer, manufacturer.

NS This is an important point. Each of the artists is engaged in serious thought, but is also grappling with complex and often extremely difficult technical problems. How do you create a canvas the size of Albert Irvin's? How do you handle a palette knife with the

virtuosity of Kyffin Williams? In each case there are the physical necessities of the work which must be brought together with the thought process, the intellectual process, and the ability to transfer that into practical, concrete terms.

RD Which is, of course, exactly what you are doing with photography.

NS Yes, it's exactly the same in photography. You're coming up with an idea and transferring it, through a controlled process, onto the photographic paper.

RD But as well as this seriousness which we have identified, I see in many artists' expressions both self-assurance and self-doubt, seemingly contradictory qualities, qualities which are, perhaps, essential for genuine artistic achievement. These are apparent even in your portraits of senior and highly esteemed artists such as Gillian Ayres and Howard Hodgkin.

NS There will be an element of self-doubt in every serious artist, because the process of making art is not only about looking out into the world and reflecting on it, but also one of continually challenging yourself, of questioning the validity of what you are doing. But a high degree of self-assurance, or confidence, is also essential, because without it you cannot take the necessary risks.

RD I also detect a strain of melancholy running through this series, a mood which also emerges in previous bodies of work – your circus photographs of the early 1980s, and in your books *The Chameleon Body* and *Franko B*. I see again and again a certain visual interplay or tension between the human face and 'visual marks' of various kinds – a clown's make-up, an artist's streaks of paint, a graffiti tag, a fetishist's tattoos and piercings, for example. Are you conscious of this current running through your photographs, and if so, what are your reflections on it?

NS Because it has been there from the beginning, yes, I am conscious of it, although it was never something I deliberately set out to create. I am aware of the fragility of the human condition, the fact that however well we conceal it, we are vulnerable and fragile, both physically and psychologically, and that there are moments when we will reflect on this. As a photographer I am far more interested in those moments than in the façade which people adopt for the camera, so I will select an image which has a contemplative and sometimes melancholic feel to it over and above a lighter, more superficial image. I feel that for a portrait to have any lasting value there must be a connection between the subject and the viewer, a resonance, a sense of engagement, exactly as there should be in the theatre, in the cinema, in literature and throughout the arts. Without this sense of engagement the potential for the image to connect is lost, and while society at any given moment seems to be more concerned with the façade, my own interest is in peeling back that layer and suggesting a thought process beneath it.

[1] David Sylvester, *Interviews with Francis Bacon*, Thames & Hudson 1993, p.120.

Biography

| 1954 | Born in London |
| 1973-6 | Studied Fine Art at the University of Newcastle upon Tyne |

Solo Exhibitions

1983	Gardner Arts Centre, University of Sussex
1985	Photogallery, St Leonards-on-Sea
1986	Photography Centre of Athens, Greece
1995	Brighton Museum and Art Gallery
1996	Tom Blau Gallery, London
1997	Brighton Museum and Art Gallery
1999	Luciano Inga-Pin Gallery, Milan, Italy

Selected Group Exhibitions

1985	The National Theatre, London
1989	Northern Centre for Contemporary Art, Sunderland
1990-1	British Council Touring Exhibition of Germany
1993	Angela Flowers Gallery, London
1994	National Portrait Gallery, London
1995	Joseloff Gallery, University of Hartford, USA
1995	Tom Blau Gallery, London
1997	Kunsthalle, Vienna, Austria
1997	Galerie Rudolfinum, Prague, Czech Republic
1998-9	National Portrait Gallery, London
1999	Padiglione d'Arte Contemporanea, Milan, Italy
1999	Culturgest, Lisbon, Portugal
2000	Caterina Gualco Gallery, Genova, Italy
2000	Musée de l'Elysée, Lausanne, Switzerland

Public Collections

National Portrait Gallery, London
Victoria and Albert Museum, London
Staatsgalerie, Stuttgart, Germany
Folkwang Museum, Essen, Germany
Musée de l'Elysée, Lausanne, Switzerland

Acknowledgements

With special thanks to:

Dorothy Bohm
Susan Bright
Judith Burns
Nicola Coleby
Robin Dance
Ann Elliot
Jill George
John Gill
John Hoole
Dave Illman
Ian Jeffrey
Denis and Joan Jackson
Helena Kovac
Kate Lewis
Honey Luard
Professor Norbert Lynton
Dr David Alan Mellor
Lucy Myers
Margaret O'Brien
Terence Pepper
Clare Slemeck
South East Arts
Sam Taylor-Wood
Sir Kyffin Williams
Rosalie Williams
Frank Youngs

s|e
a south
 east
 arts